IMAGES
of America

COTTONWOOD

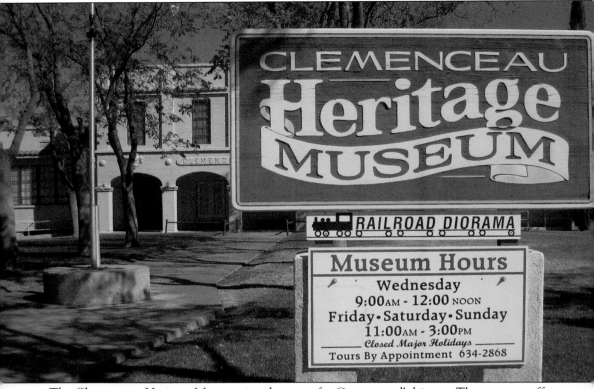

The Clemenceau Heritage Museum is a showcase for Cottonwood's history. The museum offers permanent displays of a schoolroom, early home interiors, and a model railroad diorama with replicas of the communities of Cottonwood, Clemenceau, Clarkdale, and Jerome. A major display room is changed annually with exhibits that focus on local history. The museum is operated entirely by volunteers from the Verde Historical Society and is open to the public free of charge. It occupies one wing of the Clemenceau School, built in 1923–1924 by the UVX Mining Company. The other wing houses the Cottonwood Oak Creek School District offices.

ON THE COVER: Cottonwood's Main Street in the early 1950s was a bustling commercial hub for the entire Verde Valley. With several eateries and a few bars, groceries, clothing, furniture, appliance and hardware stores, a movie theater, civic center, hotels, and even a modern "auto court" motel, Cottonwood more than met the daily needs of area residents and visitors.

IMAGES
of America

COTTONWOOD

Helen Killebrew and Helga Freund
with the Verde Historical Society

ARCADIA
PUBLISHING

Copyright © 2011 by Helen Killebrew and Helga Freund with the Verde Historical Society
ISBN 978-0-7385-7999-3

Published by Arcadia Publishing
Charleston, South Carolina

Printed in the United States of America

Library of Congress Control Number: 2011931726

For all general information, please contact Arcadia Publishing:
Telephone 843-853-2070
Fax 843-853-0044
E-mail sales@arcadiapublishing.com
For customer service and orders:
Toll-Free 1-888-313-2665

Visit us on the Internet at www.arcadiapublishing.com

To the men and women, past, present, and future, who, through their foresight, perseverance, hard work, helping hands, and joy of life, made and continue to make Cottonwood a very special place to live.

Contents

Acknowledgments		6
Introduction		7
1.	The Beginning	9
2.	The French Connection	41
3.	The Three "R"s	55
4.	In Service	65
5.	Doctor, Lawyer, Merchant, Rancher	81
6.	Time Out	101
7.	The City	113
Bibliography		127

Acknowledgments

Cottonwood is not like other cities in Yavapai County, or even in the state of Arizona. In addition to the original commercial district, now known as "Old Town," and its surrounding residential area, three distinct communities—Smelter City, Bridgeport, and the Verde Villages—are all considered part of Cottonwood, as well as several newer subdivisions. Every resident will mention one of these areas of residence when asked, "Where in Cottonwood do you live?" All have a Cottonwood, Arizona, mailing address, even if not part of the incorporated city. A fourth community, Clemenceau, a self-contained smelter company town, existed until 1960 when it was annexed by the City of Cottonwood.

The authors would like to thank the governing board of the Verde Historical Society for its positive support throughout this project. Special thanks go to the many volunteers who make the Clemenceau Heritage Museum possible with hundreds of hours of volunteer work, as well as to the descendents of Cottonwood's early families who so graciously shared photographs and personal histories. And we would like to thank our editors, Jared Jackson, Stacia Bannerman, and Kristie Kelly, for their assistance and patience.

We did all we could to make this book as error-free as humanly possible. Unless otherwise noted, all photographs appearing in this book are from the archives of the Clemenceau Heritage Museum.

INTRODUCTION

Archeologists regard the Verde Valley as an aboriginal melting pot where at least four prehistoric cultures intermingled. Tuzigoot, Apache for "crooked water," is the remnant of a Sinagua village erected between 1125 and 1400 AD. It stands on the summit of a ridge that rises above the floodplain on the north side of the Verde River, in direct line of sight from Cottonwood's Main Street. The site was excavated between 1933 and 1934 as part of the New Deal, giving out-of-work copper miners employment and new skills. There are several more unexcavated Sinaguan ruins on other rises along the Verde River and its tributary, Oak Creek. It is believed that the Sinagua, Spanish for "without water," lived in the area since about 600 AD, originally as dry farmers living in pit houses. By 1125, they began to build masonry structures and large pueblos on hilltops and mesas and constructed irrigation ditches for their crops. No one knows for sure what became of the Sinagua; the most popular theory is that a long period of drought forced them to move elsewhere.

The first Europeans to view the Cottonwood area were in the party of Spanish explorer Antonio de Espejo, who arrived in May 1583, twenty-four years before the English founded Jamestown. Other Spanish explorers briefly appeared in the valley, but with little hint of the riches they sought, combined with the hostility of the native Apache, further exploration was abandoned.

It was not until 1865, following the establishment of Prescott as the capital of the newly formed Arizona Territory, that the first small group of settlers ventured into the Verde Valley, settling near what is now Camp Verde. They found a green and grassy valley with flowing streams, fertile river bottom soil, plentiful game, and all the resources a pioneer would need to live well. They also found native Yavapai and Apache tribes who had called the Verde Valley home for centuries, and who, understandably, were often hostile to the settlers. It was not long before conflicts arose between the settlers and the indigenous people, and within a few months, a garrison of troops was sent from Prescott's Fort Whipple to protect the new settlement, leading to the establishment of Fort Lincoln (later moved and renamed Camp Verde).

By 1866, the garrison consisted of 129 men, a major market for local farm produce. Raids continued, and in 1871, the US government set up a reservation for the Yavapai, extending 40 miles up the river from Camp Verde and 10 miles on either side of the river, including much of present-day Cottonwood. Unfortunately, the raids continued, and in February 1875, the US Army, acting on an executive order from Pres. Ulysses S. Grant, transferred an estimated 1,500 Yavapai and Apache from the Rio Verde Indian Reserve to the Indian Agency at San Carlos on a forced march of 180 miles. The removal—known as the Exodus—of the indigenous people of the Verde Valley resulted in several hundred lives lost and the loss of several thousand acres of treaty lands promised to the Yavapai-Apache by the US government.

The Yavapai-Apache remained in internment at San Carlos for 25 years. When finally released, only about 200 actually made it back to their homeland in the Verde Valley. What they found

when they returned was that their land was taken over by Anglo settlers and that there was no longer a place reserved for the Yavapai-Apache people in their own homeland.

Soldiers from Camp Verde were probably the first Anglos to settle in Cottonwood when troops from the 6th Cavalry and the 9th Infantry were stationed there in 1874. This military protection, along with the forced eviction of the Yavapai-Apache, encouraged the opening of Cottonwood to permanent settlement by homesteaders. Eventually, small homes and outbuildings dotted the river bottom.

The early settlers, for the most part, came on the strength of reports from friends and relatives who had seen, either in passing or from living there, the abundance of the valley's attractions. The large majority of them were people with families, solid, God-fearing folk who wanted to make a home and a good new life and were willing to work hard to accomplish those goals. Back then, land was acquired by the simple act of claiming it. A man staked his claim by selecting a site that pleased him, built his house or pitched a tent, marked off the area he thought he could care for and defend, and that was pretty much it.

While the earliest homesteaders in the Verde Valley were dependent upon meager income from the sale of hay, grains, and farm produce to the local military garrisons and Fort Whipple in Prescott, two events of major economic importance took place in the late 1870s and early 1880s. First, in 1877, prehistoric copper mines at Jerome were rediscovered, and second, the railroad pushed into Arizona, reaching Flagstaff in 1882. The latter meant that raising stock was economically profitable, and vast herds of cattle were built up throughout the entire area of Northern Arizona wherever grass and water were available, and the Verde Valley had both. From the 1880s through the early years of the 20th century, heads of cattle in the thousands grazed in the Verde Valley.

Meanwhile, mining in Jerome hit its stride in the 1890s. Some of Arizona's richest copper lodes were found there, turning the small mining camp into a raucous boom town and resulting in the formation of two smelter towns—Clarkdale in 1912, and Clemenceau five years later.

More and more settlers were arriving in the Cottonwood vicinity, several families having traveled by wagon along the Santa Fe Trail from the east, others from California and Nevada. Farmland was sold to newcomers by homesteaders who were eager to invest in cattle or ready to move on.

Charles Douglas Willard, often referred to as the "Father of Cottonwood," arrived in 1879, driving a herd of cattle from Pine Valley, Nevada, with his father and three brothers. In a collection of reminiscences, *Pioneer Stories of Arizona's Verde Valley*, he described his first view of the Verde Valley from a mountain pass ten miles from Cottonwood:

"As I looked down into the valley, I beheld a green swath extending southward as far as the eye could see. This proved to be the river bottom of the Verde, covered with trees and vines . . . The trees being in full leaf presented a picture of greenery not often seen, and no doubt accounted for the name given to the river and valley . . . The grass was knee high and as thick as it could stand."

The Willards, along with the Bristows, Strahans, Wingfields, Scotts, Masons, Jordans, Stemmers, VanDerens, and Garrisons, were among the very early families that settled in what was to become the town—and then the city—of Cottonwood. Their hard work and determination to succeed, coupled with a spirit of community, sowed the seeds that grew into today's Cottonwood, a very special place for those of us lucky enough to live here.

One

THE BEGINNING

In the last quarter of the 19th century, cattlemen and travelers often camped overnight under a circle of big Cottonwood trees that stood near the Verde River, just north of where the old jail now stands, and this location became known as "the Cottonwoods." About this time, word spread about the lush riparian area and mild climate, attracting hardy settlers. The Yavapai-Apache had been rounded up and sent south to San Carlos. Between Fort Verde's military camp and the copper mines of Jerome, there was a ready market for agricultural produce. Thus, Cottonwood's beginnings, at least until World War I, were as a farming community with a small general store and a post office, established in 1885, with the official name of Cottonwood, Arizona Territory.

As early as 1908, pioneers Lon Mason and Charles Stemmer pulled a drag through brush, laying out Cottonwood's Main Street. It took another several years and a world war for the town to spring up, when owners of land along Main Street began to subdivide after the Clarkdale and Clemenceau smelters came into existence. One and sometimes two-story buildings were constructed with one storefront per lot, and beyond Main Street on both sides, further subdivisions called additions created small lots for homes.

As the town grew and prospered, so did the influx of newcomers—Italians, Czechs, Yugoslavs, and Mexicans—especially those seeking business opportunities outside the restrictions of the two company-run towns. In fact, with the opening of the Clemenceau smelter, Cottonwood emerged as a rough little town with some bootlegging, a town madam, and even some shootings in the streets, with a duel over a poker game ending in death.

From the very beginning, fires had a major impact on Cottonwood's development, as early buildings were of wood frame construction and Main Street was lined with a wood boardwalk. The worst, in 1925, took out three-fourths of Main Street's west side, and another in 1933 destroyed half a block on the east side. Downtown changed as a result of the fires. With few exceptions, wood was no longer used for new construction, and concrete sidewalks replaced boardwalks. Today, Cottonwood's "Old Town" looks much the same as it did in the 1930s; the majority of buildings date from the 1920s and 1930s—those that either survived the fires or were rebuilt as a result of them.

Cottonwood was settled by people who stayed and whose families played an integral part in the history and development of the area.

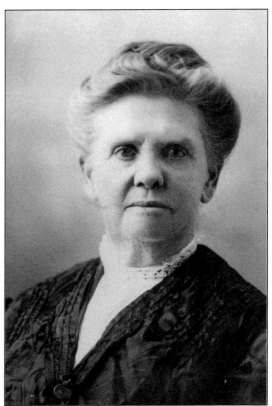

Mary Grace Willard, matriarch of one of the area's most influential families, arrived in Cottonwood in 1884 with her other children to join her sons Charles and Dolph, who had arrived in 1879. They, their father, Joel, and brothers Ninian and Alex, had driven cattle from Pine Valley, Nevada, looking for greener pastures. Joel died of pneumonia on the trip, and tragically, both Alex and Ninian drowned in the Verde River soon after settling in Cottonwood.

This three-story Queen Anne–style house was built for Mary Willard with bricks manufactured on site; the lime for mortar came from the cliffs on the other side of the Verde River. Completed in 1890, it was considered very elegant, with a fireplace in every room and a Steinway square piano upstairs. It is still standing at the north end of Old Town, listed in the National Register of Historic Places. Mary Willard is the woman in black, surrounded by daughters, daughters-in-law, and grandchildren.

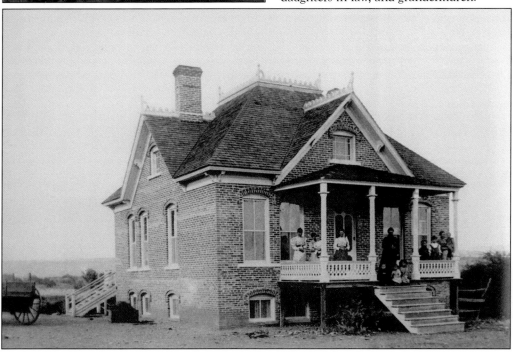

Charles D. Willard, often called the "Father of Cottonwood," posed for this photograph at the time of his marriage to Etta Jane Scott in 1890. Charles was an enterprising young man, responsible for much of the development of Cottonwood.

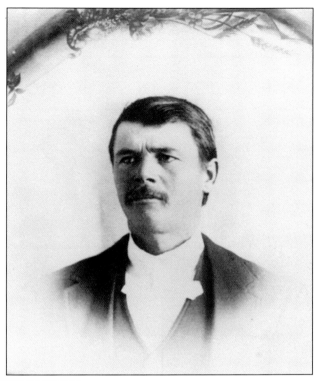

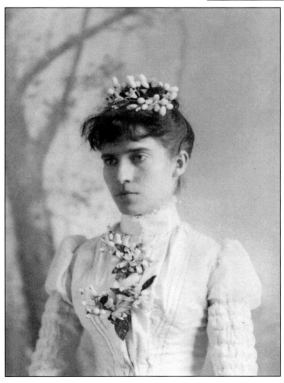

Etta Jane Scott, of another Cottonwood pioneer family, married Charles Willard on June 11, 1890, with Rev. R.A. Windes officiating. This wedding picture was signed "E.M. Jennings, Photographer and Artist," with "the best instruments in the Territory." Etta and Charles had two boys and four girls.

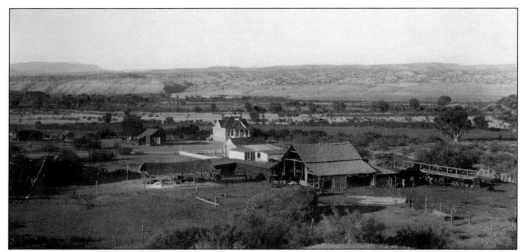

Charles Willard built his home across the road from his mother's and started one of the area's earliest dairies with deliveries to Jerome twice a day. He later bought the Jerome Dairy from the Strahans and operated it for about five years before selling out to newly arrived Italian families.

The Colonial Revival home of Alexander Strahan, at the opposite end of Main Street from the Willards' place, was built using brick from the Willards' kiln. The Strahans settled in Cottonwood in 1878 and deeded land for both the first school district and cemetery. Sadly, the house, which had been vacant for many years, was demolished in 2007, despite being listed in the National Register of Historic Places.

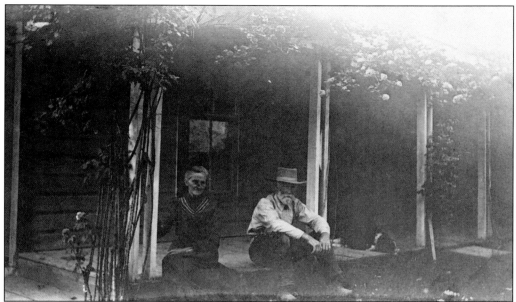

Alice and David Scott enjoy a quiet moment on their front porch. The Scotts arrived in 1883 with six children, a married daughter with her husband, and their three children. They settled near the river crossing that came to bear their name in the area of today's Aspen Street and ran a gristmill for corn and wheat, using water from an irrigation ditch for power.

A capable and attractive young lady, Luna Birdena Scott, like her sister Etta Jane, married a Willard, George "Mack" MacDonald, a younger brother of Charles. Mack became Cottonwood's first postmaster in 1885. The sisters enjoyed riding over to old Grandma Hawkins near Pecks Lake to eat one of her boiled dinners and listen to her stories from earlier times as she smoked an old corn pipe.

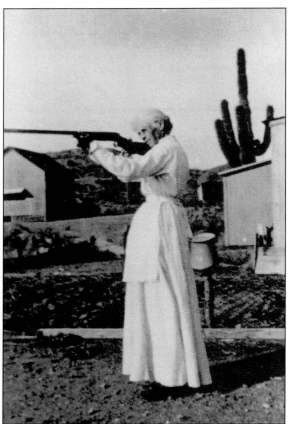

Rev. Romulus A. Windes was the first ordained Baptist minister. He and his wife, Maggie, lived in the Verde Valley between 1886 and 1899, where he organized churches at Cottonwood and Jerome. Maggie Windes kept a tongue-in-cheek journal, *Home Talent*, "devoted to its own business," describing the area's goings-on. Of Mr. and Mrs. Strahan's baptismal service in August 1895, she wrote, "We mean a baptism, not a little dribble dabble of water splashed in the face. We have now nine members in our church."

Parson James C. Bristow spread the good word with his Gospel Wagon. He preached the first Baptist sermon in Arizona on October 3, 1875, under a cottonwood tree, having recently arrived in an ox-drawn wagon train from Missouri with his wife and six children. With the help of Reverend Windes, he became pastor of the first church in the Verde Valley. He preached his last sermon at the Old Tree on October 3, 1920, and died soon after at the age of 86. His son W.P. Bristow followed as a Baptist minister.

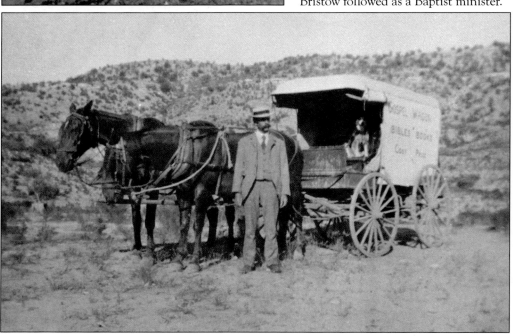

W.A. "Will" Jordan married Annie, daughter of Parson Bristow, in 1889. Will arrived in the Verde Valley from Maine and homesteaded in Clarkdale in 1886, on a site that later became the Clarkdale smelter's slag pile. Will relocated, buying dry farmland in Sedona and river property between Scott and Thompson Crossings in Cottonwood, where he and Annie built their home to be near Annie's father. Sons Walter and George settled on the Sedona property.

The Jordan home is located on Mingus View Road, Cottonwood. The six-bedroom, two-story wood frame house was completed in June 1913. The house had three screened porches and a hand pump well just outside the kitchen door. The chimney of the back-to-back fireplace between the dining room and parlor is three stories tall. The home is now the residence of Andy and Mary Beth Groseta.

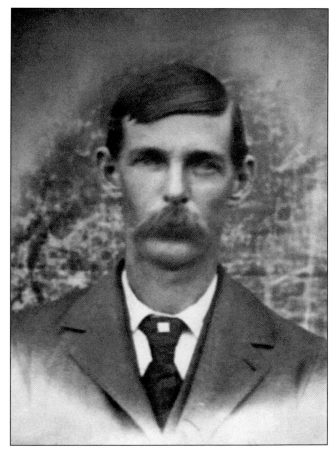

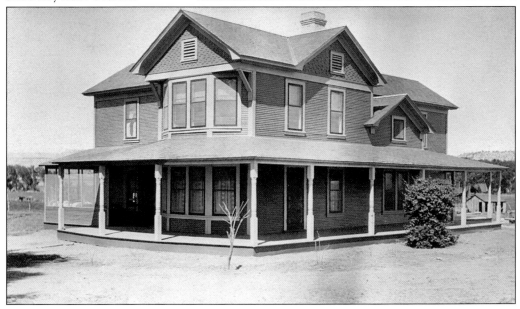

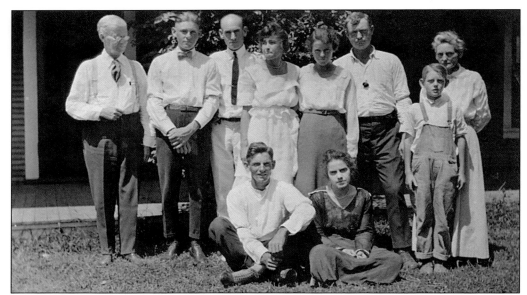

The Jordan family gathered for a photograph around 1922 with five of their nine children. They are, from left to right, (seated) Willy and his wife Hazel Whitney, who moved to California to start an avocado farm; (standing) Reverend Windes, Sumner, Edward Stone, his wife Mary (Jordan), Alice, her husband Bill Gray, Edgar, and Annie.

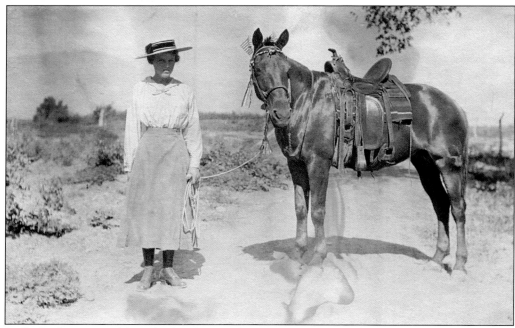

Stella Jordan enjoyed horseback riding, and for patriotic occasions such as the Fourth of July, decorated her steed with American flags, as in this 1918 photograph. Stella taught school in Cottonwood and Clemenceau for many years and never married. She lived in the Jordan house until her death in 1973, willing it to her nephew Charles Jordan.

Most farm operations included running some cattle, and many families had a mountain or summer camp above the Mogollon Rim. Bill Gray, pictured here, had several cattle and horse ranches; an area between Cottonwood and Sedona was his winter range, and Bill Gray Road is named for him. He married Alice Jordan, Stella's sister.

Godfrey Van Deren, seen here with his wife, Elizabeth Ann (right), and a sister, crossed the desert from California, arriving in Cottonwood in 1879. With a total of 11 in the family, they settled on land between the Jordans and Bridgeport. They raised horses and cattle and intermarried with the Scotts, Grays, and Zaleskys. A brother, Walter Van Deren, never married and was a popular fiddle player for dances.

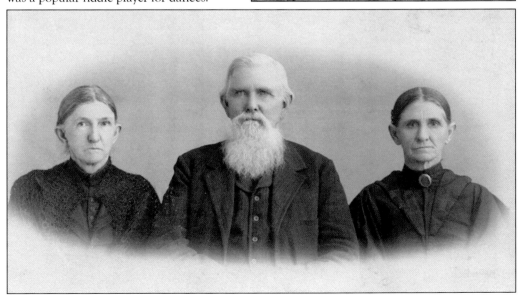

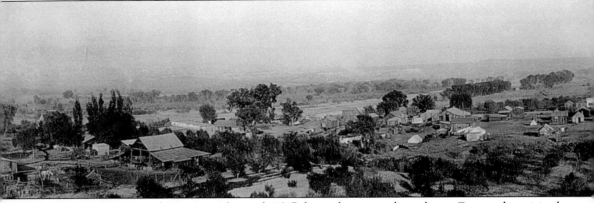

A panoramic view of Cottonwood in early 1917 shows the town taking shape. Cactus, the original commercial street, is in the foreground; Main Street runs parallel beyond. Charles Willard's dairy barn can be seen at far left. A water company, started by Charles from artesian wells on

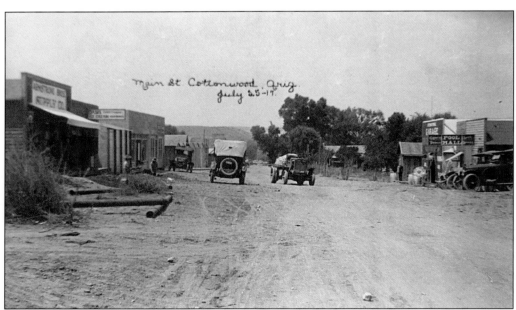

The building of the smelters in Clarkdale and Clemenceau made Cottonwood a desirable place for development. Main Street was laid out using mules to pull a heavy wooden beam, called a drag, along the property line of the Willards and Strahans. A buying frenzy started in 1917. Business lots were going for $150 to $200 and residential lots for $100 to $150. Terms were $25 down and $10 per month at no interest, with five percent off for cash. The lots were soon sold out.

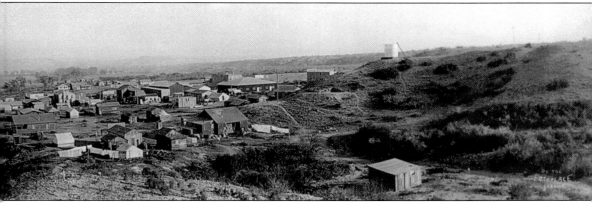

the Willard property, provided water for the new community. In the next few years, both sides of Main Street were subdivided and building lots sold.

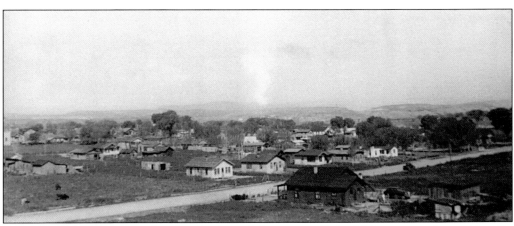

Beyond Main Street on both sides, further subdivisions called additions created small lots for homes. Many of the new residents had makeshift homes in the form of tents and tent houses. The *Verde Daily Copper News* of September 24, 1917, noted, "A great many people are encamped on the outskirts of town, who would rent houses in Cottonwood if they could secure them at a rental of $15–18 month for two to three room residences."

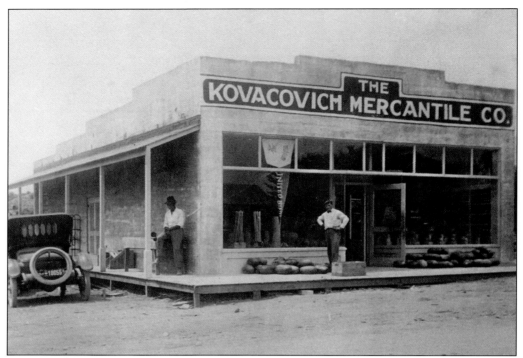

The Kovacovich Mercantile was built in 1917 on the corner of Main and Cactus Streets. It was Cottonwood's first concrete building and is now the oldest commercial building in the city. As all travel up and down the valley passed through Cottonwood, farmers from Oak Creek and Cornville found Kovacovich's to be their most convenient marketing place.

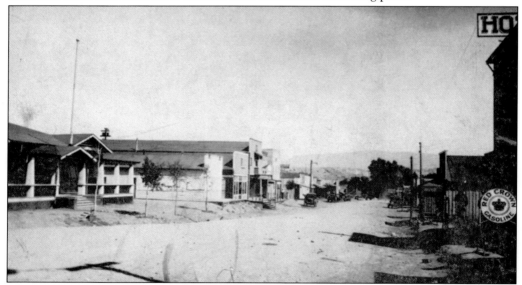

The Bungalow, at far left, opened in May 1917 to much fanfare. It was advertised as one of the most attractive amusement halls in the Verde Valley. With 5,200 feet of floor space, an elevated stage for orchestras, a wide veranda with benches, and electric lights, it was meant to cater to the "best classes of patrons."

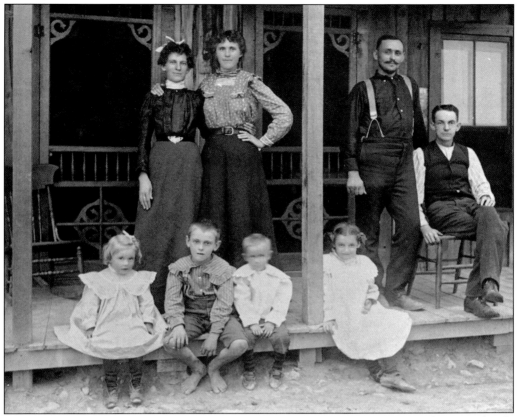

The Garrison family also featured prominently in Cottonwood's development. This 1900 family photograph features, from left to right, (first row) Effie, Ersel (who grew up to marry Jennie Willard, daughter of Charles and Etta Jane), Ernest, and Elizabeth; (second row) Lola, mother; Aunt Ida; William Robert, father; and friend Jink Crawley.

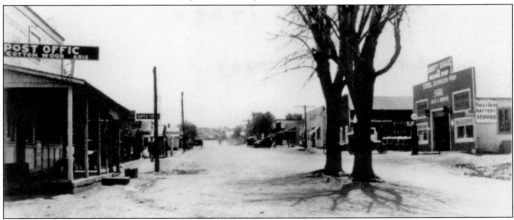

By the early 1920s, Cottonwood had its own post office building. Ersel Garrison, soon to be Charles Willard's son-in-law, opened a Ford dealership and service station, the Liberty Garage. The dealership, with some revisions, later became the Cottonwood Water Company. A few of the original cottonwoods still stand in this view looking south along Main Street.

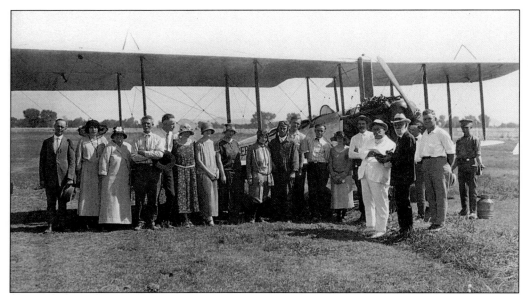

On June 10, 1924, Ersel Garrison and Jennie Willard flew to Phoenix in Ersel's plane to be married at the state fairgrounds by Reverend Windes, who had married Jennie's parents in 1890. After the ceremony, they planned to fly to San Francisco for their honeymoon. They crashed on take-off; they were unhurt, but the plane was wrecked. Governor Hunt came to the rescue, giving the couple a ride in his car, speeding after a westbound train until they caught up with it in Peoria, Arizona.

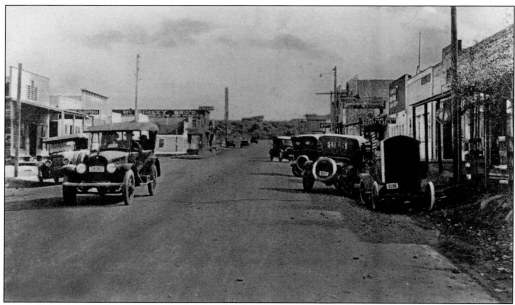

In the early 1920s, Cottonwood was a bustling little town, boasting electricity and phone service at $48 a year for businesses and $36 for residences. Buildings and sidewalks were still of wood, and in April 1925, another major fire swept down the west side of Main Street, destroying 16 businesses and killing one man in the Cottonwood Hotel. It was thought that a man operating a hot dog stand put a box of hot ashes between the buildings, and wind fanned the ashes into a conflagration.

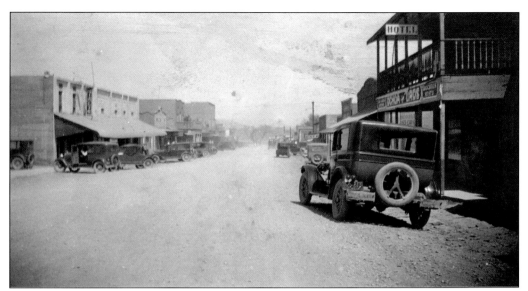

By the late 1920s, the west side of Main Street had been rebuilt using cast or poured concrete, and buildings boasted large display windows. Both sides of the street had concrete sidewalks, thanks to the efforts of the Progressive Association, a predecessor to the Chamber of Commerce.

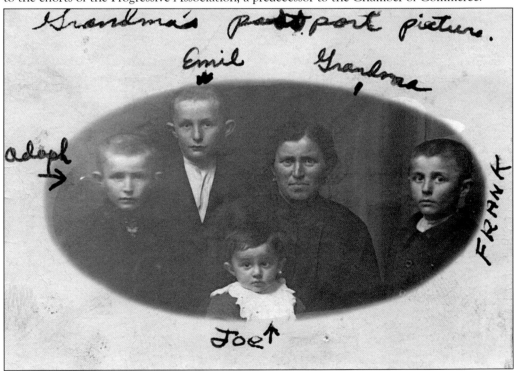

In the 1920s, many folk from other states, as well as Europeans and Mexicans, came to Cottonwood attracted by work in the mines, smelters, commerce, and agriculture. The Monginis, shown in their Italian passport photograph, were one such family. They soon got into the dairy business, eventually acquiring the large UVX Dairy. Little Joe was later a mayor of Cottonwood.

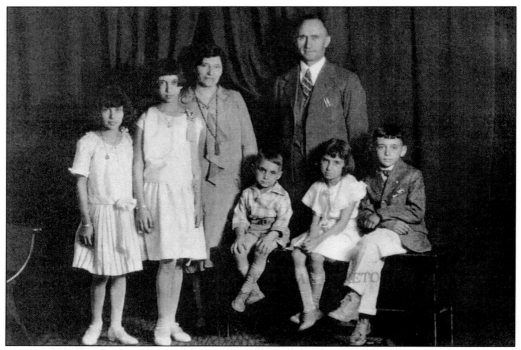

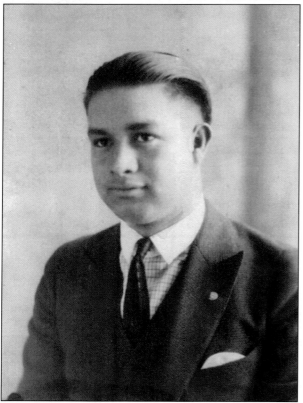

Joseph Becchetti came from Italy in 1903 and worked in mines in Michigan before coming to Arizona. He moved to Cottonwood in 1920 and was soon in the entertainment business. Carrying his own generator, he created portable movie theaters. He opened his first movie house, the Rialto, in Cottonwood in 1921. He and his wife, Ermelinda, are pictured on the Rialto stage with their children, Helen, Rachel, Donny, Josephine, and Frank.

Ernesto Ochoa's father came from Mexico to work in the smelter. For several years, the family lived in a tent. Ernesto put himself through Lamson Business College in Phoenix, learned the grocery business, and in 1923, married his sweetheart, Emma. He bought two lots on First Street for $250 each and began building their home one room at a time. He played the trombone with the Paramount Players every Saturday night for 15 years.

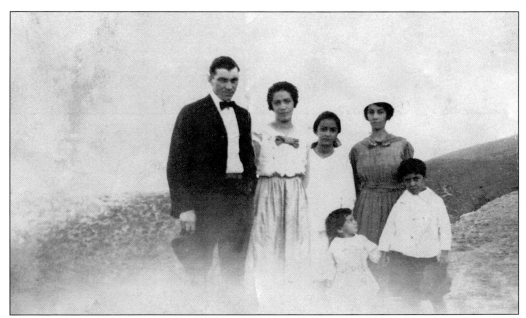

Roy Dale arrived in the Verde Valley after his discharge from the Army in World War I. He had his own business, Roy Dale's Electric Shop, and built a house for his family on Fourth Street, Cottonwood. This photograph was taken on his wedding day, August 6, 1917. He is standing next to his bride, Lydia Gonzales, with Lydia's two sisters, Lucy and Lupe, and Lupe's two children.

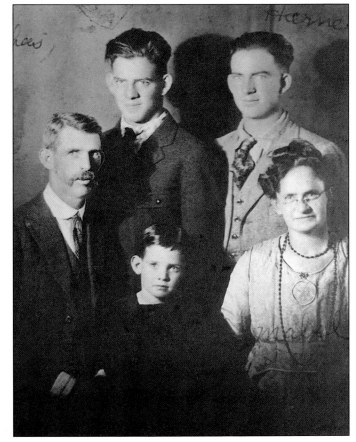

For many years, Dr. J.T. Taylor was Cottonwood's only family doctor. He had an office on Pinal Street. Here he is with his family in the early 1920s, with sons Charles and Harness Ellis, standing, and the youngest, John Thomas Jr., seated between Dr. Taylor and his wife, Mabel.

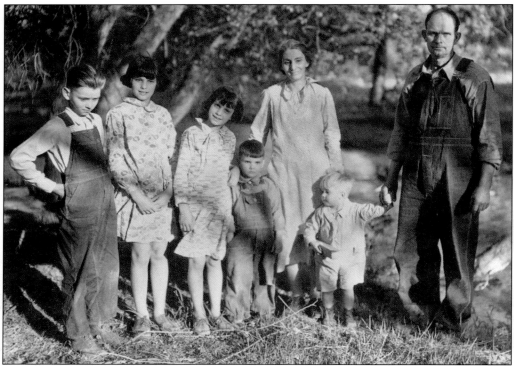

Ed and Retha Wright farmed in the Verde Valley for several years. This 1931 photograph shows them with five of their 11 children—Glen, Nell, Mary, Paul, and Larry. Another son, Ed, bought a restaurant in Smelter City that he named the Chatterbox Café, a popular teen hangout. Ed raised his own beef in a field east of the Cottonwood Cemetery, and his wife, Opal, was known for her pies.

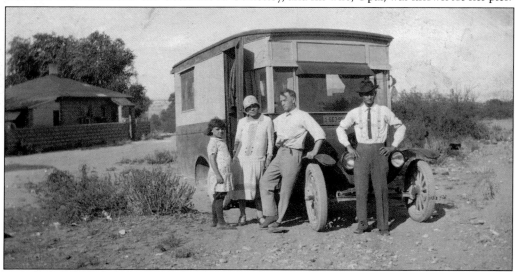

People continued to come throughout the 1920s however they could, drawn primarily by the prospect of finding work. The Ragles arrived from Missouri in a truck converted to living quarters, a predecessor of the RV. He was a painter and had received a contract to paint houses in Clemenceau, so they moved to Cottonwood in 1927.

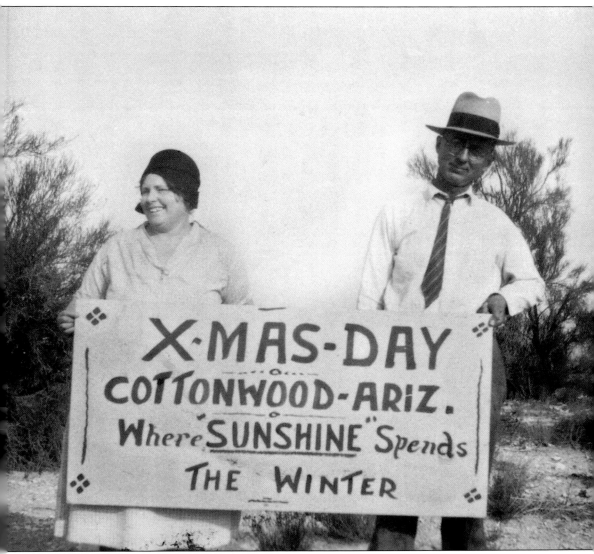

Phelan W. Ragle Sr. and his wife, Floy, express their delight in Arizona's winter climate. More than a house painter, Phelan was also a sign painter, and his work was seen all around the Cottonwood area on buildings and signboards. They had four children—Osley, Arl "A.K.," Phelan Jr. "Dub," and Billie Jean. Osley was one of three original members of the board of education when Cottonwood started its own high school in 1947.

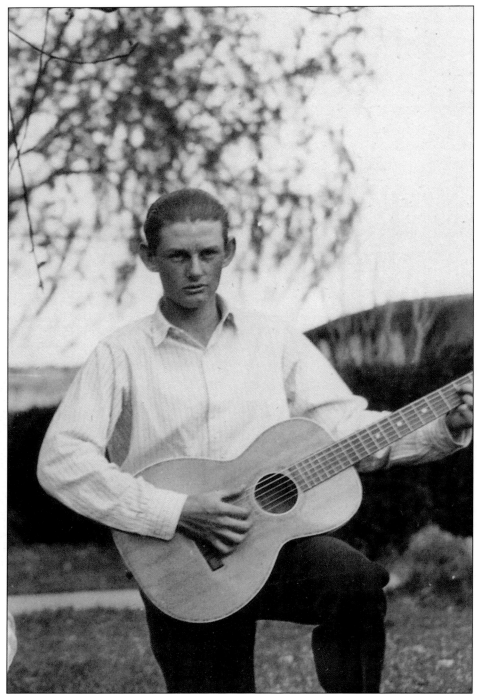

The youngest Jordan child, Edgar, shown here around 1925, was a bright young man who enjoyed playing the guitar with friends. He was also somewhat of a dandy, especially when it came to hats. The correspondence on the next page took place shortly before his untimely death. He was killed on a road trip outside Yuma while trying to fix a broken headlight on the car.

Here is the letter Edgar wrote about returning the hat because the crown was too high, and the polite response from Sears, Roebuck and Co., the "World's Largest Store," sending him the sum of $3.89, including charges paid for shipping, with the hope of having further opportunities to serve. Note that the address was not Cottonwood, but Clemenceau.

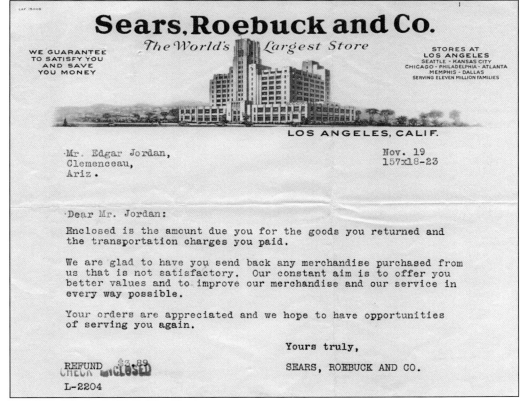

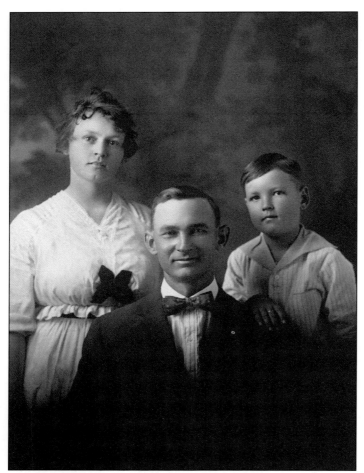

James Otto "J.O." Braley, wife, Permelia, and son, Bill, moved to Clemenceau in 1916, where he worked as a mechanic for the smelter. He then opened Braley's Garage in Cottonwood, which later became the local Dodge dealership. This photograph was taken in 1917.

In 1930, J.O. built the Braley Auto Court, a motel designed to allow travelers to house their automobiles in a covered carport next to their room. It was one of the first motels with such a design. In 1933, son Bill, "J.W." Braley built Braley's Auto Supply between the garage and auto court. In the 1940s, the senior Braleys opened Braley's Malt shop across the street from the Rialto Theater in Cottonwood.

John Muretic immigrated to Arizona at the age of 19 from Croatia; first to Bisbee, and later to Jerome, where he worked in the mines. His wife, Barbara, joined him in 1928, the occasion for this photograph. They bought some property in Bridgeport in 1931. Their farm grew from a family garden to selling produce, hay, and butchered meat; all the while, John continued to work in the Jerome mine.

The Muretics purchased the Braley Motel in 1945, changing the name to Alamo Motel. A year later, John bought Shep Package Liquor across the street, quit working at the mine to renovate the motel room next to the street, and moved the liquor store over there, changing its name to John's Package Liquor. Both John and Barbara became very active in civic organizations.

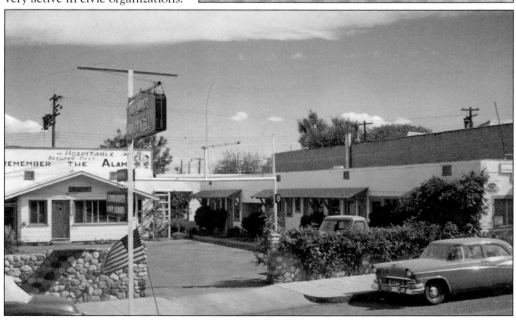

In 1933, catastrophe hit again, this time on the east side of Main Street. A blaze starting in a coffee urn at the Eat-Mor Sandwich Shop destroyed the McGimsey building, a clothing store, and two residences, then crossed Pima Street to ignite tents of a traveling carnival in the park now occupied by city hall. Again in February 1934, fire destroyed four businesses and a residence on the corner of Pinal Street, where the Cottonwood Café was later built.

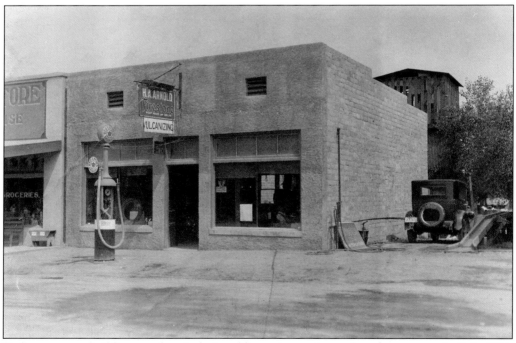

Earlier concrete buildings, such as Jack Arnold's service station and auto parts store, built in 1925, the Valley Café, and Verde Valley Distributing Company one block south, withstood the flames and became the standard for future buildings on the east side of Main Street.

Everything needed to keep an automobile going was available in Jack Arnold's neatly stocked store. He later divided the building into two stores; one half became a beauty parlor, the other J.O. Braley's service station. Later, the empty lot next door became Lindner's Chevrolet, Pontiac, and Oldsmobile Dealership. (Lindner photograph courtesy Phyllis Garrison Lindner.)

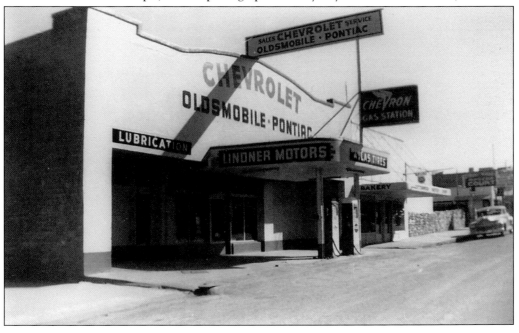

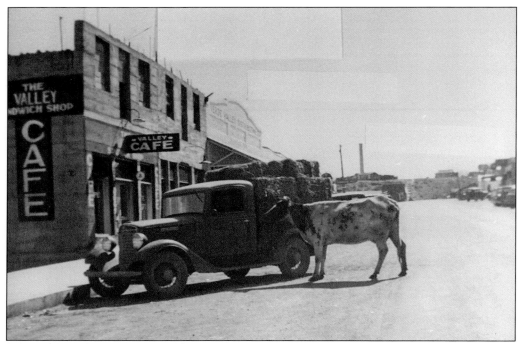

Several Cottonwood residents owned milk cows in the 1920s–1930s. The animals often wandered from their yards, looking for choicer pastures. What could be more tempting than a truckload of sweet hay?

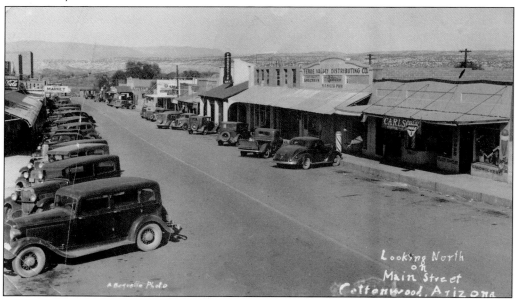

By the late 1930s, the east side of Main Street boasted Carlson's "Always the Best" ready-to-wear, a barbershop, Siler's Grocery store, a café, the Progressive Market, two bars, the Cottonwood Café, John's Liquor Store, Braley's Motor Court and service station, a beauty shop, and a new jail built by the county in 1929 at the foot of Main. The names and businesses have changed, but Main Street looks very much the same now as it did then.

Smelter City, formed from the Scott property in 1918, was just north of Clemenceau on the other side of the cemetery from Cottonwood. Among those to settle there were the Valazzas. Pete and Claudina grew up in Italy, and in 1915, homesteaded 160 acres on what is now South Sixth Street. They bought the store in 1923 and built a home next door. Pete delivered groceries to Mexican Town, next to Clemenceau, first by horse, later by car. They had three children, Dino, Bruno, and Eros.

Bridgeport, by the original Thompson Crossing, also saw development with the building of the first bridge across the upper Verde. Bud Lysons and Ralph Durnez are at the window of the newly constructed gas station around 1924. Just to the right of the building was a café and dance hall, a popular Saturday night destination for area residents in the new era of automobiles.

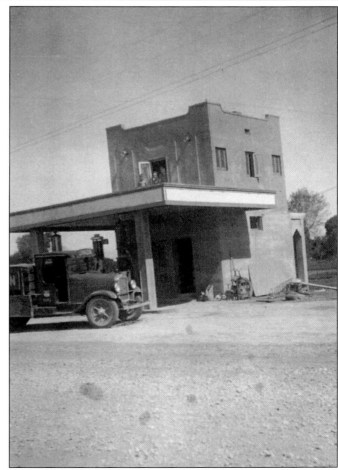

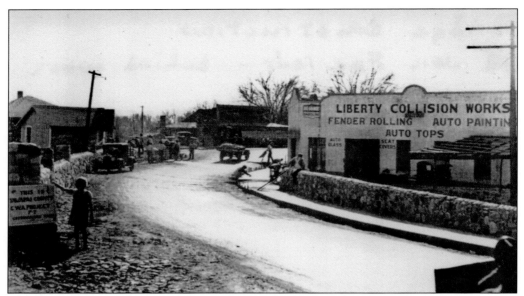

The Great Depression hit Cottonwood. In early summer of 1930, both smelters curtailed production, and hundreds of miners and smelter workers lost their jobs. Federal relief programs provided assistance. In 1934, the Civil Works Administration (CWA) rebuilt the Cottonwood Bridge at the north end of Main Street. Liberty Collision Works served as field office for the work-relief groups.

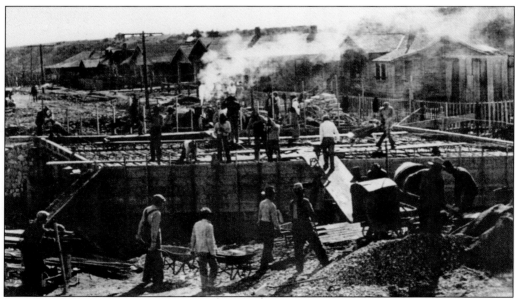

In 1935, the Works Progress Administration (WPA) constructed Del Monte Wash Bridge at the south end of Main Street and went on to build an entrance to the cemetery. Earlier, in 1933, several Civilian Conservation Corps (CCC) projects benefitted Cottonwood. These included excavating Tuzigoot and building a visitor center, and road and restoration work in the countryside. The workers frequented downtown businesses and the projects helped develop tourism.

Catherine Robinson sits on a wheelbarrow as construction begins on the Cottonwood Civic Center by the WPA in 1939. The Cottonwood Women's Civic Club raised enough money through bake sales, dinners, and other fundraising events to get the project started. The building served as a gathering place for the entire community into the 1970s.

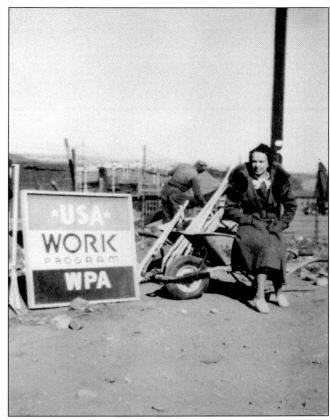

Workers smooth the concrete for a basketball court on one side of the recently completed civic center, built of native river rock. The civic center was used for a variety of events, public meetings, scholarship fundraisers, plays, and local talent nights, bringing the whole town together.

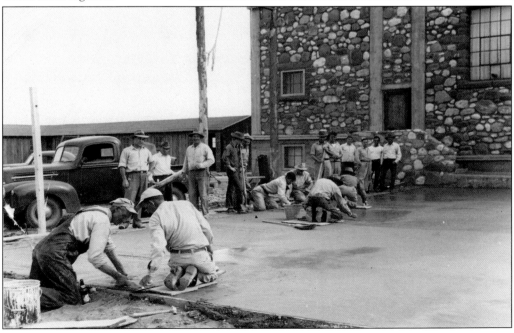

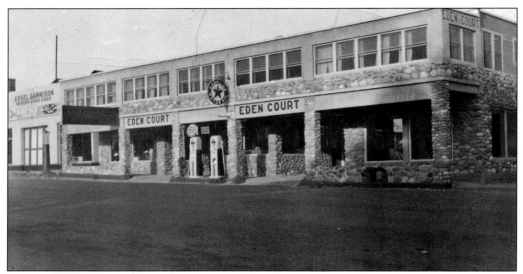

Despite the Depression, the 1930s saw some new enterprises other than the public works projects. In anticipation of more tourism, William F. Eden, owner of Cottonwood Lumber, built Eden Auto Court next to the Liberty Garage out of river rock, which was free for the hauling.

Another new business was Verde Floral, Cottonwood's first and now oldest florist, which had its beginnings in the garage of John and Debbie Calvert in 1939 on Main Street across from Fourth Street. It was financed with $2,000 borrowed from Valley National Bank. Cut flowers were kept cool in an old icebox, and steam heat for the greenhouse was hand operated, which meant the Calverts had to get up three times a night to let steam run through the pipes.

Wealthy easterners Marcus J. Lawrence and his mother came to the Verde Valley in 1931 and bought the V Bar V Cattle Ranch. Marcus enjoyed the nightlife in Prescott and became involved in a love triangle with another man's wife. The husband caught them, beat the pair, and Lawrence died of a massive brain hemorrhage. Headlines read, "Rich playboy found in tryst with lusty gambler's woman and ends up dead."

Perhaps the most significant building project was that of the Marcus J. Lawrence Clinic, a memorial to her son by Carrie Lawrence. She had first thought of building a bridge in his memory, but Dr. A.C. Carlson convinced her that a clinic would be of greater service. It began as an outpatient clinic with offices, an operating room, and an X-ray, expanding in 1945 to become a hospital. Lawrence remained a major contributor, establishing a trust fund in 1939 to pay for its maintenance.

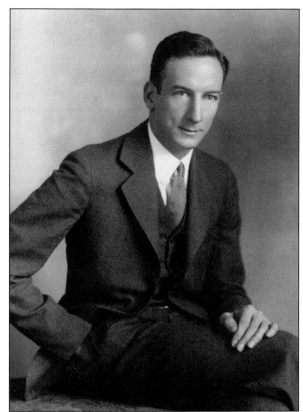

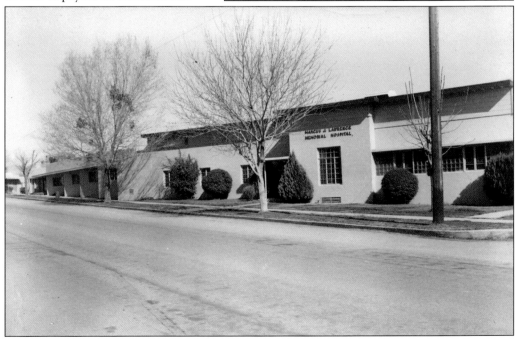

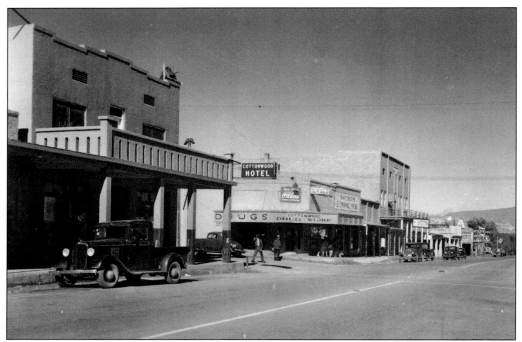

The west side of Main Street in the late 1930s shows the two-story Cottonwood Hotel in the foreground with the volunteer fire department's bell on the roof. After the devastating 1925 fire, the town ordered a chemical engine mounted on wheels with a water and chemical hose attached. The fire department was made up entirely of volunteers until after Cottonwood incorporated in 1960. The street remains much the same, other than the vintage of the cars.

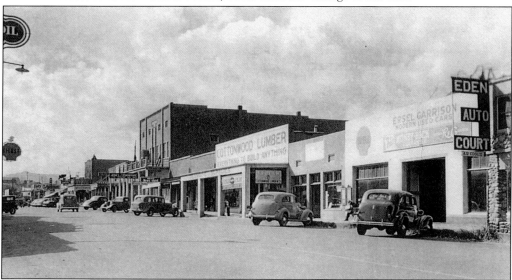

By the beginning of World War II, Cottonwood was a commercial hub for the Verde Valley, referred to as the "Biggest Little Town in Arizona" by local businessmen. This view, looking south, shows the 1927 two-story Willard Building, which had a skating rink and dance hall on the second floor, and was the place for public meetings prior to the building of the Civic Center.

Two

THE FRENCH CONNECTION

In 1915, James Stuart Douglas, also known as "Rawhide Jimmy," the Crown Prince of Copper, and the son of Dr. James Douglas (after whom Douglas, Arizona, is named), staked a claim in Jerome in a promising spot missed by others. With the Little Daisy Mine, Douglas struck rich ore and proceeded to establish the United Verde Extension Company (UVX). The mine was a bonanza, yielding $52 million in dividends before it shut down in 1937. To process the ore in 1917–1918, Douglas built a smelter on a large tract of land he acquired just to the southwest of the small town of Cottonwood, and to accommodate the hundreds of smelter workers needed, he built an entire town, which he named Verde.

However, in 1920, the US Post Office notified Douglas that there were too many "Verdes" in the state and asked him to change the name. He renamed the town Clemenceau in honor of his good friend, Georges Clemenceau (1841–1929), affectionately known as the "Tiger" by the people of France. He was a noted French statesman and served twice as premier of France, from 1906 to 1909 and again during World War I. Douglas had become a close friend of Clemenceau while serving with the Red Cross in France during the "war to end all wars."

In addition to a post office, the bustling company town consisted of 80 frame houses, a general merchandise store, bank, amusement hall, clubhouse, gazebo, tennis courts, grocery and drugstore, and dormitories for single men. In 1923, James Douglas also donated land and built the Clemenceau Public School for all the children in Clemenceau and Cottonwood from kindergarten through ninth grade. The school was completely furnished and opened in the fall of 1924. Half of the building still holds the offices of the Cottonwood Oak Creek School District, while the other half is home to the Clemenceau Heritage Museum.

While the smelter closed on December 31, 1936, the town of Clemenceau held on until it was annexed by Cottonwood in 1960, when the latter incorporated. Its remaining houses were demolished in 2008. The only buildings testifying to the existence of the community of Clemenceau are the school, the Clemenceau Water Company, and the Bank of Clemenceau, which was moved to a location on the Clemenceau Public School grounds. It has been restored and is now a part of the Clemenceau Heritage Museum. In addition, a few of the brick smelter office buildings remain, along with two substantial brick homes built for the master mechanic and the smelter supervisor.

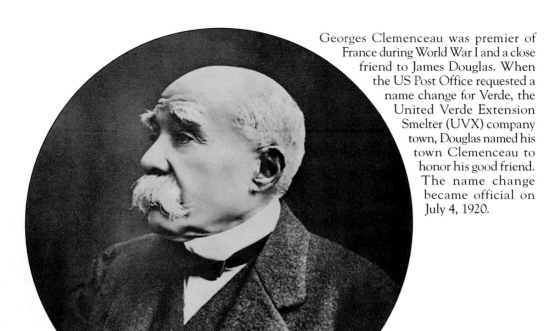

Georges Clemenceau was premier of France during World War I and a close friend to James Douglas. When the US Post Office requested a name change for Verde, the United Verde Extension Smelter (UVX) company town, Douglas named his town Clemenceau to honor his good friend. The name change became official on July 4, 1920.

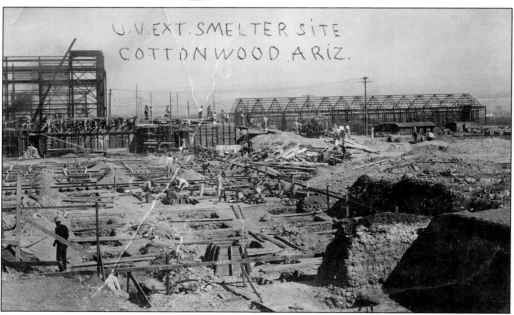

Construction of the UVX smelter began in 1917. Until its closure in December 1936, it offered employment to several hundred men each year, attracting workers and their families from near and far, greatly contributing to the growth of the area.

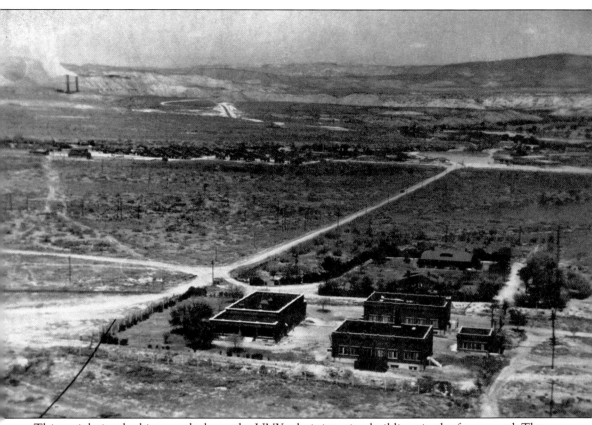

This aerial view looking north shows the UVX administration buildings in the foreground. The road, now Willard Street, intersects with what is now Mingus Avenue to the town of Clemenceau on the left. The Clemenceau Public School is located to the right of the crossroad. Clarkdale's smelter stacks can be seen in the distance.

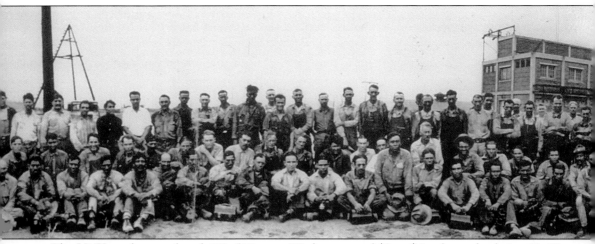

The UVX smelter employed 400–500 men. Workers earned $3 to $6 a day, a day being 10–12 hours long. A clinic on the premises with one doctor and one nurse provided health care for the men and their families. The smelter was close to the company town so a short walk got them to

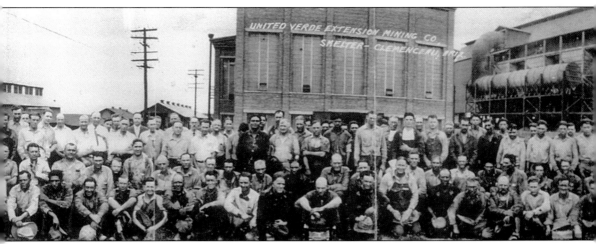

work. Some workers rented small pieces of land for tents on the outskirts of the town site. A few Indians built a settlement of their own outside the town.

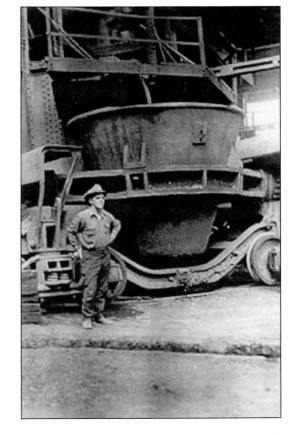

UVX smelter superintendent, Mr. Prince, looks small beside the ore dumpster. Machinery used to operate a smelter is massive and in operation every day of the week. The downside to the smelting operation was the acid smoke polluting the air. From the 1920s to the 1940s, it was nearly impossible to grow anything green because of the smoke.

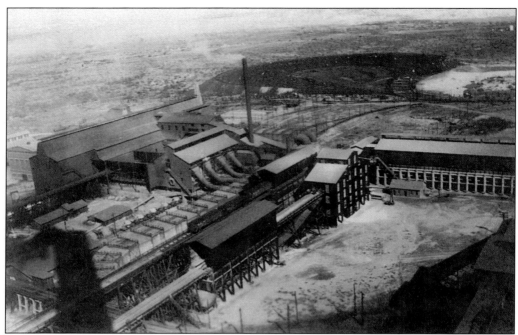

The UVX smelter was constructed with reinforced concrete several feet thick. It handled 500 tons of ore each day, brought in by rail from the Jerome mine. There were cooling ponds behind the electric shop, used by children as a swimming pool. The shadow of the huge smokestack can be seen at lower left.

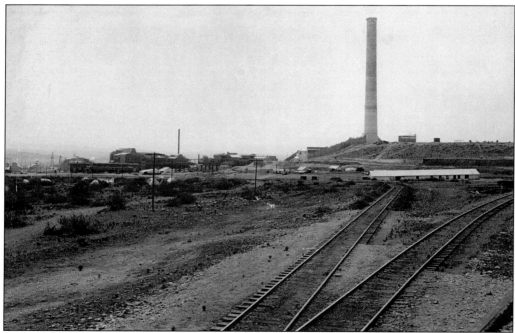

This view of the UVX smelter and stack shows the railroad tracks leading to the smelter from the Little Daisy Mine in Jerome. The smelter stack was 425 feet tall, the highest in the world.

Bunkhouse construction began in August 1917. Each wood frame house was 12 feet by 300 feet and held 60 men. Smelter workers numbered in the hundreds, so while waiting for construction of other bunkhouses, the men often slept in shifts rather than on the ground in tents.

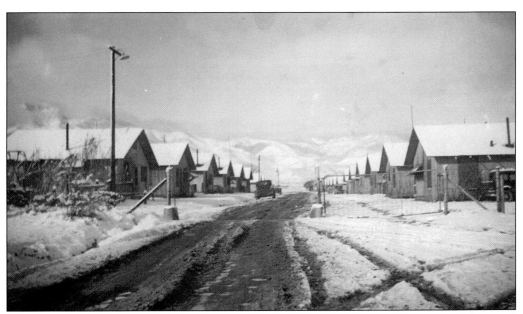

Eighty row houses were built in 1917 in Clemenceau, seen here after a heavy snow. The wood frame houses each had an outdoor privy called a "chick sale." Toilet rooms were added on to the rear of the houses in the 1930s.

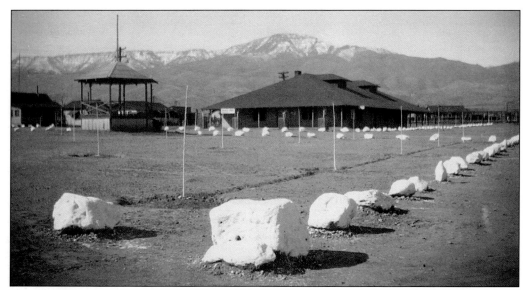

The clubhouse was a large open building with a fireplace on one side and a bar at the end. Dances were held here almost every Saturday night with live bands. The gazebo was a favorite gathering place. Decorated for every holiday, it hosted orators, band concerts, recitals, weddings, and birthday parties, and was a fine place to sit and visit with a neighbor.

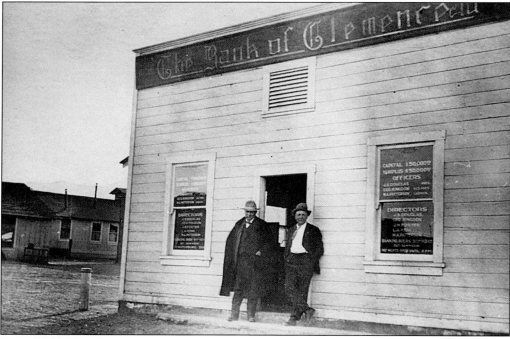

Jimmy Douglas and George Kingdon pose in front of the Bank of Clemenceau, which was in operation from February 1, 1921, to November 17, 1933. The bank became the Clemenceau Post Office on July 1, 1934, and continued until July 31, 1954. A rural carrier dispatched mail to Cornville, Rimrock, Pine, and Payson, Arizona. Today, the building is part of the Clemenceau Heritage Museum.

Billie Jean Teague was a Star Route mail carrier from July 1, 1946, to July 31, 1954. She delivered mail along the road from the Clemenceau Post Office, through Smelter City and Bridgeport, to the post office in Cornville. Postmistress Jessie Chick separated the mail, and Billie continued her run to McGuireville and Rimrock. Mail was separated in Rimrock for the post office in Clemenceau. The entire trip took about three hours.

A 1932 Ford was used by Billie Jean Teague to transport mail from the Clemenceau Post Office to Cornville and Rimrock. Sideboards were installed in back to hold the sacks of mail, which were really heavy when Sears, Roebuck & Co. and Montgomery Ward sent out their catalogs each season.

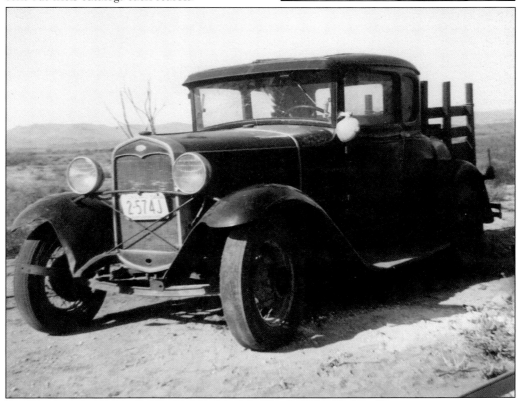

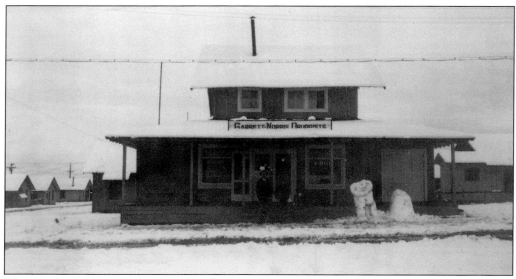

John Garrett's drugstore also served as the first Clemenceau Post Office. Garrett was a prominent Arizona pharmacist who came to the Verde Valley in 1919. He owned and operated drugstores until 1965.

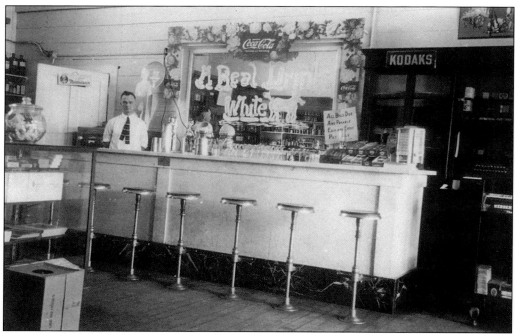

The drugstore not only dispensed medications; its soda fountain was a popular hangout. It was the place to purchase magazines, candy, cigarettes, and film. Garrett, behind the counter, also made really good malts, shakes, and sundaes.

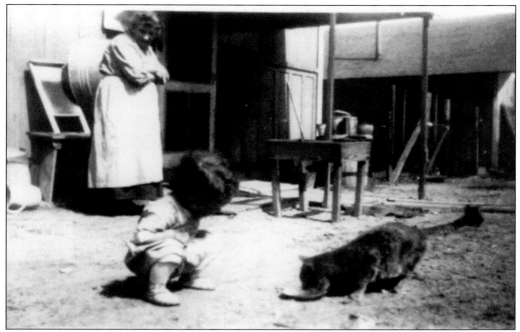

A child watches her cat slurp up milk as grandma looks on. Notice the hand washboard in the background. Life was not so easy then. Doing the laundry was a backbreaking job that took up most of a day.

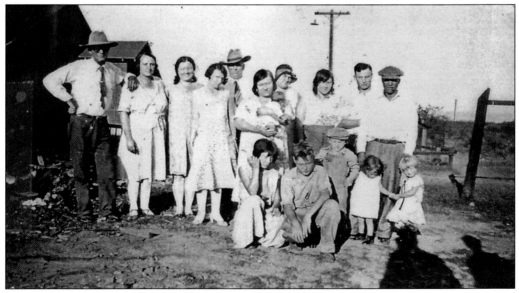

A July 4, 1931, Ohlwiler family reunion includes the Conders, Petersons, and Uptons. Get-togethers like these happened frequently, and were often recorded with a Kodak Brownie Box Camera.

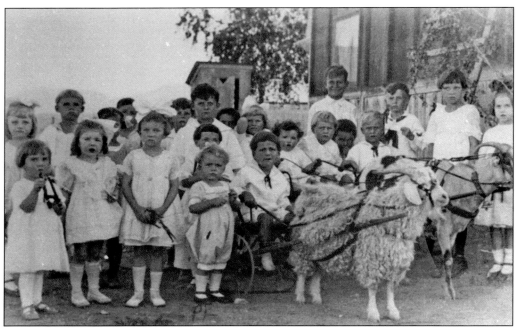

Sheep and goat carts provided entertainment at this upscale birthday party in the early 1920s. Note the "chick sale" in the background. Among the partygoers are Virginia Foster, Peggy Kruse, Jesse Mae Foster, and Shirley Hagais.

Phelan W. Ragle Sr. (right) came to Cottonwood in 1927 with his wife, Floy, and four children. He had received a contract to paint houses in Clemenceau. Ragle is pictured with an unidentified friend in front of houses to be painted or possibly already painted.

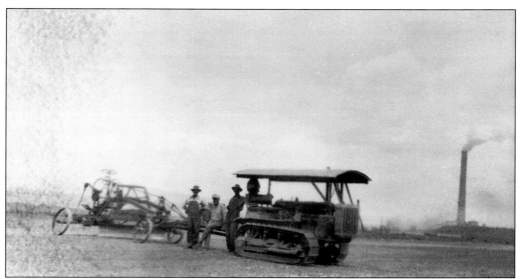

In early 1932, a caterpillar tractor dozed the brush to make a smooth runway for the Clemenceau Airport. In the background is the UVX smelter smokestack, which served as a landmark for the airport. Impromptu air races were sometimes held between the Clemenceau and Clarkdale stacks.

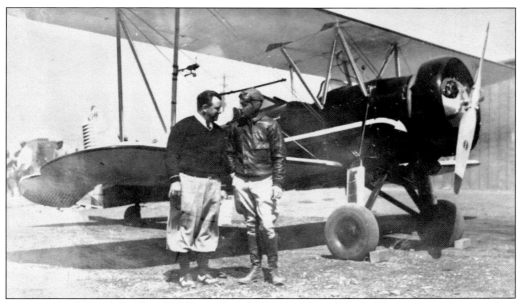

Instructor Jack Lynch (left) and William Clark III, heir to United Verde Copper, were photographed just minutes before their fatal last flight on May 15, 1932. Clark had been instrumental in bringing about the construction of the Clemenceau Airport, forming a corporation to establish the Verde Valley Airlines, scheduled to begin flights in July 1932. Those plans were abandoned upon his death.

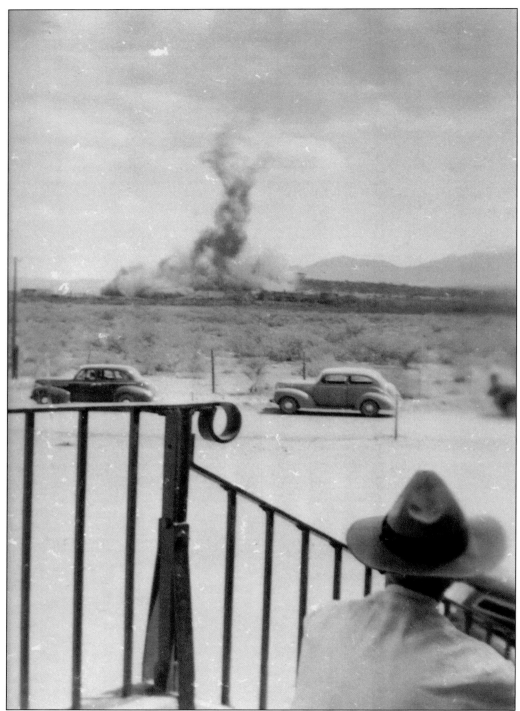

The 425-foot-tall United Verde Extension Smelter smokestack was demolished in 1948, here seen from the steps of the Clemenceau Public School. People from all over the valley watched the smokestack come down. Some brick rubble remains today.

Three

THE THREE "R"S

Education was uppermost in importance for the early settlers. The very first school in the Upper Verde was built in 1877, when there were not even half a dozen adobe or log homes, often windowless. The school of unplastered adobe was built on a site now occupied by the Cottonwood Community Civic Center. According to the recollections of Luna Berdina Willard, it had one table, one chair, 12 long homemade seats with desks of equal length, a box stove, tin water bucket, a blackboard, one map, Webster's unabridged dictionary, two boxes of chalk, and a large bottle of ink from which small bottles were filled.

The Upper Verde Grade School opened in 1909 at the northeast end of the present-day Cottonwood Cemetery. The teacher was paid $40 per month from a subscription taken among the parents of students. Water was carried a quarter-mile from the nearest well, and a woodstove heated the building. It also served as the meeting place for all social events. In 1932, the wood frame building was split into two portions, which were moved to their present-day locations at East Cochise and South Main Streets.

The Bungalow School was built in Verde, later renamed Clemenceau, in 1917. Its wood frame building housed kindergarten through eighth grades, with a total of 114 students and four teachers. It was there, on November 19, 1919, that the Verde Parent-Teacher Association was formed, the first in the Verde Valley, with Matilda Langdon as president. Schools were closed from October 8 through December 27, 1918, due to the outbreak of Spanish influenza.

James Douglas built the Clemenceau Public School, for kindergarten through ninth grade, in 1923–1924. It was completely furnished and donated to the students in the communities of Cottonwood and Clemenceau. From 1947 through 1958, it served as both elementary and high school for Cottonwood.

The annexation of Cornville's Oak Creek School in 1954 led to the formation of the Cottonwood Oak Creek School District No. 6. Two years later, the Willard School in Bridgeport became part of this new school district.

In the early 1970s, Cottonwood saw renewed growth, and the schools scrambled to provide for the surge in student numbers. New schools were built, including Cottonwood Junior High, Daniel Bright Elementary, and a brand-new Mingus Union High School.

Upper Verde Grade School, just north of the Cottonwood Cemetery, opened in the fall of 1909 for grades one through eight. Water was carried a quarter-mile from the nearest well, and a woodstove heated the building. It closed in 1924 when the new Clemenceau Public School was completed.

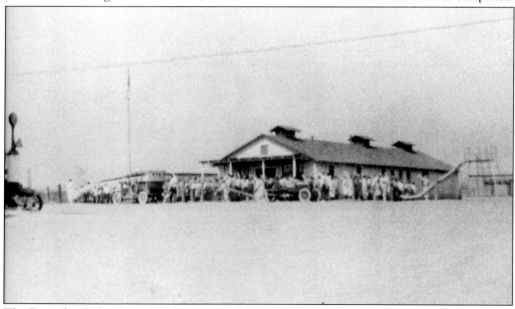

The Bungalow School was built in 1917 in Clemenceau for kindergarten through eighth grades. The bungalow-style building was wood frame and stood across the road from the commissary. It closed in 1924 when Clemenceau Public School was completed. All Cottonwood and Clemenceau students now attended the same school.

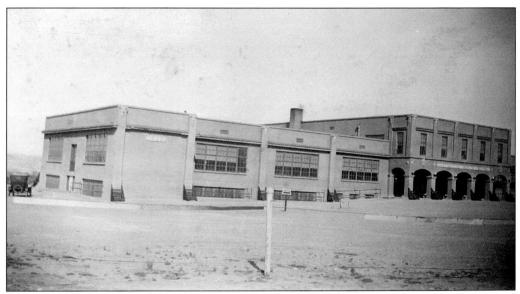

Clemenceau Public School was constructed in 1923–1924. The style is modest Spanish Colonial Revival. The school was completely furnished and donated to the communities of Clemenceau and Cottonwood by James Douglas. Kindergarten through ninth grades attended this school until 1948–1958, when it also housed Cottonwood High School. Classes in the Clemenceau Public School Building ended in 1987.

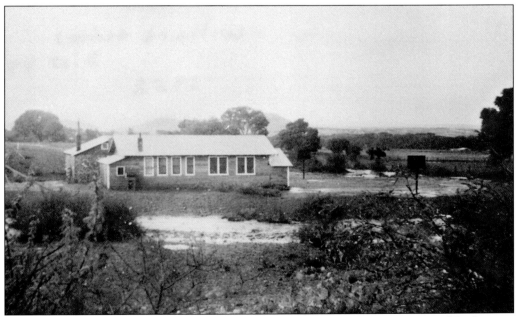

Willard School District No. 44 was constructed in the 1920s in the community of Bridgeport. The wood building had one room with a portable dividing wall. A river rock addition was built in the 1950s. Restroom facilities were two outhouses, each with one hole, 50 yards from the school. A well, with a hand pump in front of the building, provided drinking water.

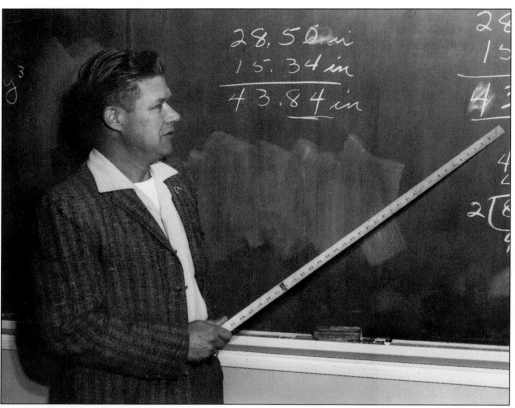

Morris Clark taught science and biology in the brand-new Cottonwood High School from its opening in 1947 through 1957. He was a no-nonsense kind of teacher who earned the respect of each of his students. He told chemistry student Helen Savage that since she could not sleep on her book and absorb the lessons, it would be best to drop the class before she flunked.

Mary Lou (Thompson) Hemler Arnold graduated from high school in Oklahoma in 1917. She moved to Cottonwood in 1928, and for the next 33 years, taught first grade. Back then, teachers were prohibited from marrying, dancing, and smoking. In 1947, she finally married William Hemler, the man she had been seeing for the past 20 years.

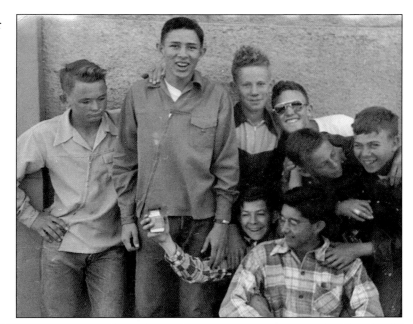

Stanley Schumacher snapped this photograph of some of the boys in his photography class, also his shop class. They are, from left to right, (standing) Neil Peterson, Jack Burkett, Dale Tasa, Elmer Foster, Robert Stotts, and Loyd "Spooks" Self; (in front) Leroy "Boze" Savage and Charlie Ochoa.

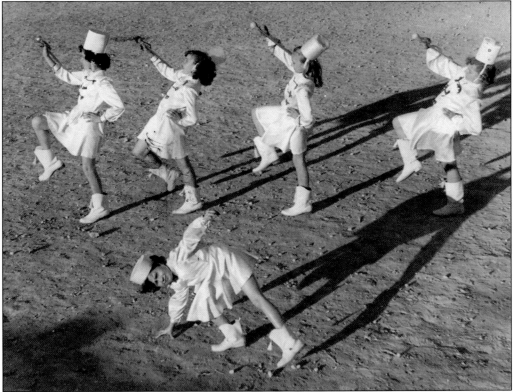

Edith Howe, bending over, was a member of the elementary twirler team, mascots to the high school twirlers. They performed in homecoming marches, halftime drills at football games, and pep rallies.

Nancy Ragle and Jack Burkett are all dressed up for the first day of school. Both were born and raised in the valley and graduated from Cottonwood High School. Nancy was a cheerleader, and Jack played all the sports available in a brand-new high school.

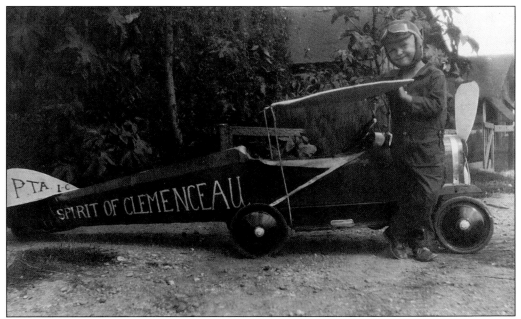

This little boy with his "flying machine" was part of a parade sponsored by the area's earliest PTA organization. It was formed in 1920 in the kindergarten classroom of the Bungalow School in Clemenceau.

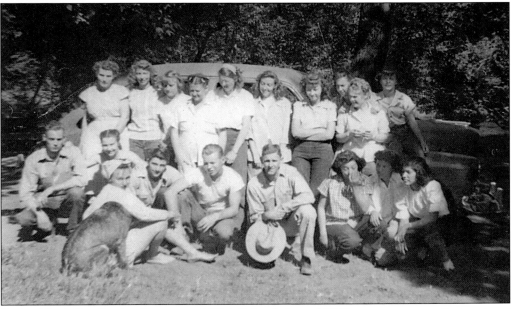

Senior Ditch Day for the Cottonwood High School class of 1949 was an opportunity to get out and have some fun. These seniors are, from left to right, (first row) Bob Willard, Helen Savage, Billie Zimmerman (with her dog King), David Wright, Fred Anderson, sponsor Henry Howe, Elisa Escalante, Mary Manriquez, Olivia Torrez; (second row) Zelma Love, Marilyn Murray, Jean Newberry, Marty Heydorn, Helen Girdner, Martha Malone, Norma Cook, Rosie Dale, Helen Black, and Ardath Kallsen.

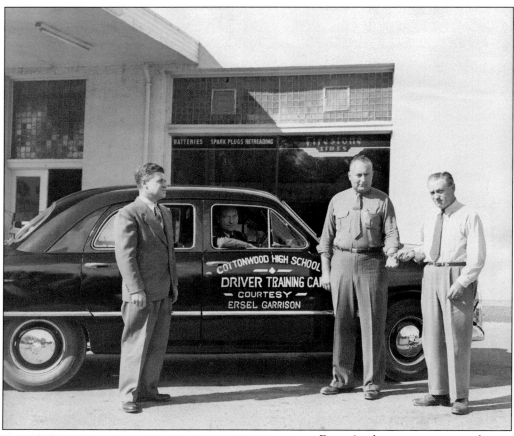

Driver's education was a popular class. Pictured standing are, from left to right, school superintendent Joseph Archambeau, school board member Osley Ragle, and Ersel Garrison of the Ford dealership, which furnished the car. Principal Fred Lewis is seated in the car in this early 1950s photograph.

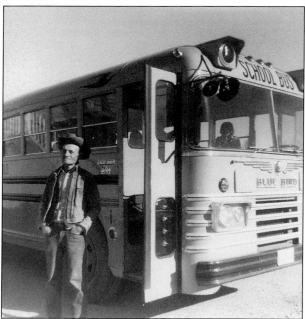

Frank Zaleski was a rancher, shopkeeper, and bus driver. He drove a school bus from the early 1940s through Cottonwood High School years and one year that students attended Clarkdale High School. His ranch was a favorite place for wannabe cowboys. Weekend rodeos had a lot of thrown riders, but no one was seriously hurt.

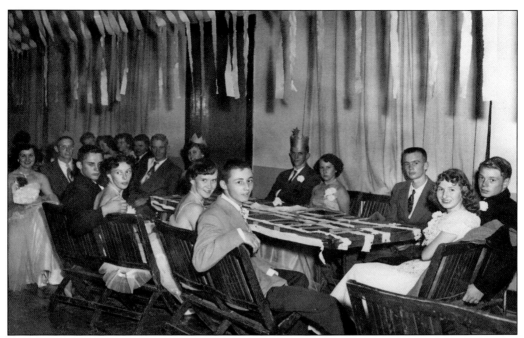

Couples at the 1953 junior-senior prom at Cottonwood High School were, from left to right (at table, backs to camera) Eddie Watts, Janice (Tissaw) Watts, Margie (Godard) Grant, Orin "Pinkie" Marvin, Carol (Thompson) Godard, and Colin Connolly. The prom queen, with crown, seated center rear, was Marilyn (Price) Olsen.

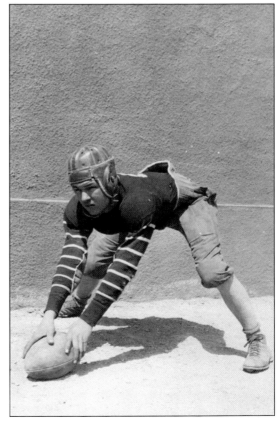

Football was a popular high school sport even back in 1925, when Bill Braley's photograph was taken as he was about to hike the ball to the quarterback. Bill's father worked as a mechanic in the Clemenceau smelter and later built Braley Auto Court in Cottonwood. Bill married his childhood sweetheart, Martha Elizabeth Jones, and ran the Union 76 Service Station in Cottonwood.

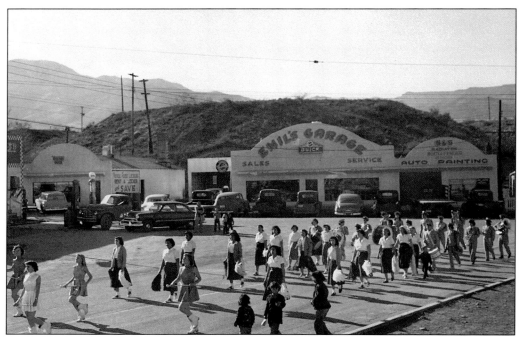

Everyone loves a parade, especially a hometown parade with the local high school band marching and playing. Homecoming was so exciting with a parade, pep rally, and finally, the game. This parade was in the early 1950s.

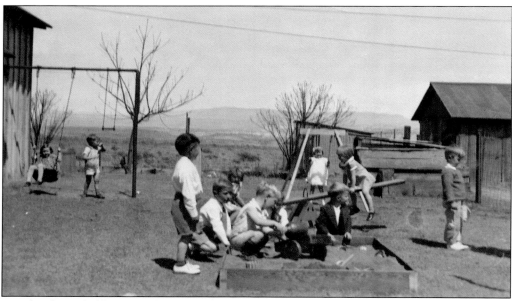

Preschool was held in a yard near the Clemenceau School and meant lots of playtime. Four-year-old Markie Barker is on the swing at left, with Beverly Johnson standing next to her. Other children in this 1937 photograph are Robert Fornara, Jim Savinio, Robert Snyder, Jim Braley, Margie Love, and Robert Snyder.

Four

IN SERVICE

Cottonwood, since its beginnings, has been blessed with people who are willing to serve, whether in answering the call to arms to defend their country, or volunteering for a cause to improve the welfare of their fellow citizens. Of course, along the way, supporting worthwhile causes is also good business and improves the lives of all.

In 1917, the *Verde Daily Copper News* noted, "Townsmen turned out several days in advance of Fourth of July to fill ruts and smooth out Main Street. Their labors were rewarded when a crowd of 3,000 came to town to enjoy the rodeo and evening dancing at the Bungalow."

The earliest civic organization was the Progressive Association, a forerunner of the Chamber of Commerce, which strove to improve the commercial district, raising funds to build concrete sidewalks, arrange for trash removal from back alleys, improve roads, secure better water pressure, and support a volunteer fire department. The majority of early businessmen were also Masons.

In 1937, Catherine Robinson called a group of women to a meeting on November 19 to discuss the possibility of a women's service club. It was formed that very afternoon. The charter members of the Community Civic Club included Jennie Garrison, Ermelinda Becchetti, Permelia Braley, Mattie Medigovich, Anna Strahan, and Vera Broughton, with Robinson as the first president. Its motto was "Work from the Heart is the Key to Achievement," and its goal "The Encouragement and Promotion of all Civic Betterments." The organization's first order of business was to build the Cottonwood Civic Center through the WPA, which they achieved through many fundraising projects and much elbow grease. With that project completed, they started the first town library and a kindergarten, and continued to raise money to send Boy Scouts to camp, provide glasses for needy children, and other worthy undertakings.

The Cottonwood Chamber of Commerce has since replaced the Progressive Association, and numerous other clubs, including Rotary, Lions, and Kiwanis, carry on the good works begun by the Community Civic Club, along with many other organizations almost too numerous to name. Volunteers play vital roles in the hospital, animal shelter, 4-H club, Old Town Mission, American Legion and VFW, Clemenceau Heritage Museum, food bank, state park, Old Town Association, many church activities, city committees, and the Chamber of Commerce, just to name a few.

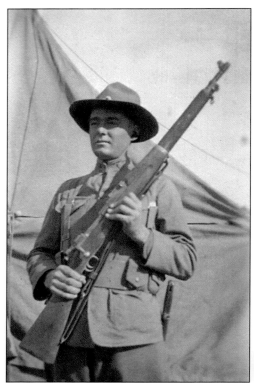

Two sons of W.A. and Annie Jordan served in World War I. Chester served as a supply sergeant in the same place as his future brother-in-law, Bill Gray. He sent home this photograph, writing on the back, "A forlorn, lonesome soldier doing post arms. The wind blew hard and I got mad; the camera snapped, so I look bad."

Chester's younger brother Willie served in the Army infantry and fought in France, where he was gassed. This photograph shows him in uniform right after the war with his wife, Hazel Whitney. He and Hazel later moved to California and started an avocado farm.

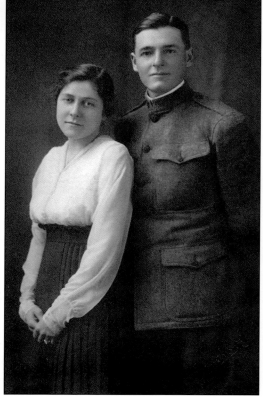

Roy Deward Dale, born July 8, 1889, in Louisville, Kentucky, came to the Verde Valley after his discharge from the Army in World War I. He acquired several mine sites near Cherry, Arizona, married a girl from Jerome, and started Roy Dale's Electric Shop in the mid-1930s. He built a house on Fourth Street in Cottonwood for his family.

Despite being discriminated against, people from the Mexican community held strong feelings of patriotism towards their adopted country. One of their most important celebrations was Independence Day, when they marched from Clemenceau to Cottonwood with flags, banners, and decorated floats and cars, as in this 1930 photograph.

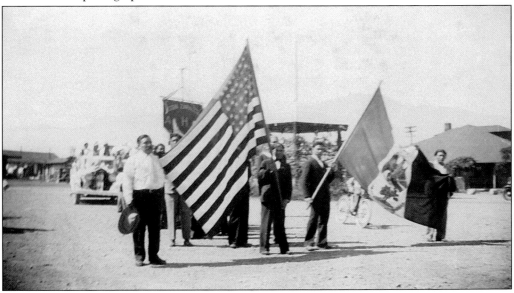

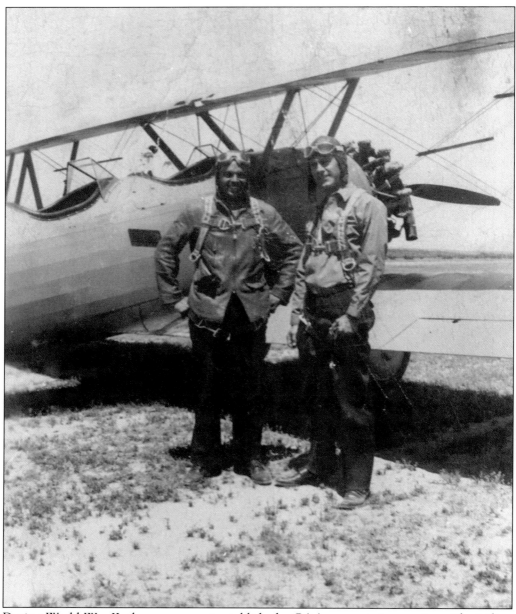

During World War II, the government established a CAA war training service with civilian instructors to train the military pilots. Because Cottonwood had an airport and good pilots, it was chosen for a naval pilot primary flight school. Training craft were Stearman biplanes. Local mechanics attended the planes.

The cadets brought new excitement to Cottonwood, giving the town a sense of contributing as a community to the war effort. Although we do not have names for the young pilots in these photographs, the dashing "flyboys" probably won many a young girl's heart.

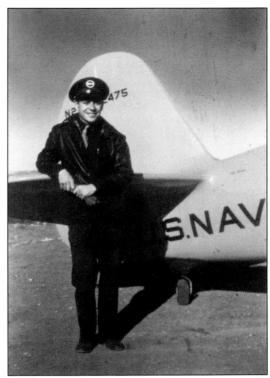

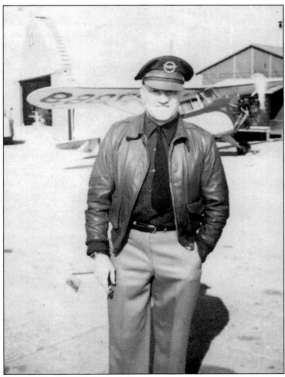

This unidentified civilian instructor was one of several area pilots who participated in the training program. The school included an airstrip, beacon, hangar, temporary buildings, and Quonset huts. One day, a B-17 circled low and parachuted a small bundle over the airport, which turned out to be a rooster. It was dubbed Delbert and became the cadets' mascot, ruling the roost.

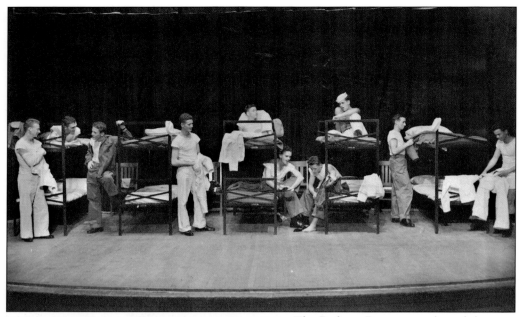

The Defense Department leased the Civic Center and filled it with bunk beds to house the cadets. It also leased the Marianna building across the street, 826 North Main Street, which was used for a mess hall.

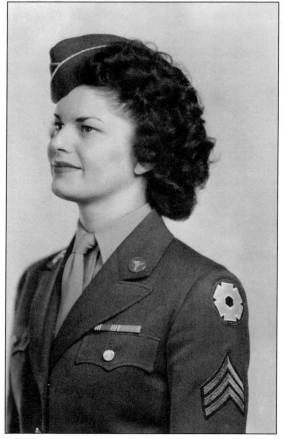

Women did their part in the war effort too, whether working in civilian jobs while their men went to the front, or in vital factory jobs, or rolling bandages for the Red Cross. Some also entered military service, such as Cottonwood's Angelina Zanetta, who served as a WAC with the Army's 6th Division in South Carolina.

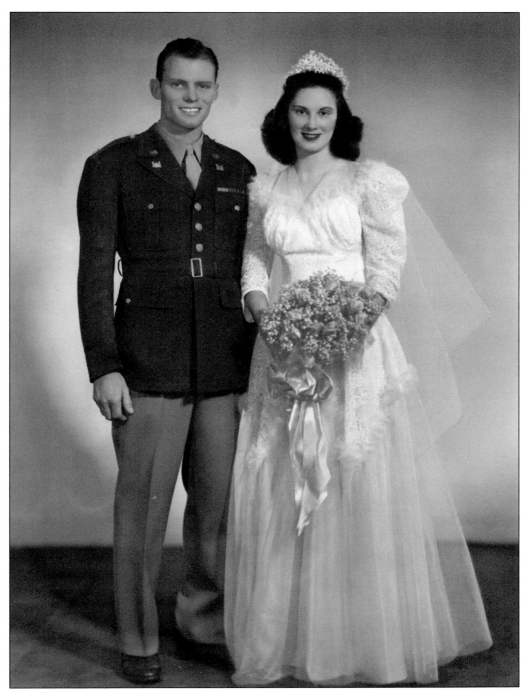

War sometimes led to romance. Glen Oliver Wright met his bride, Ruth Lillian Breyley, while in officer candidate school at Fort Belvoir, Virginia. They married on November 15, 1942. After the war, Glen returned to Cottonwood and opened a cabinet shop. Ruth not only raised a family, but also made volunteering a career, devoting decades to helping others.

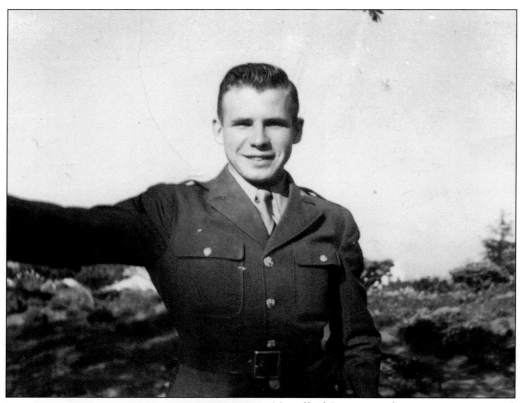

Not all of Cottonwood's young men returned home after the war. Bert Black Jr., seen here at age 19, was drafted into the Army's 4th Infantry Division in May 1943. He died near Aachen, Germany, in December 1944 and was buried at the US Military Cemetery, Henri Chapelle, Belgium. His remains were later brought back for burial.

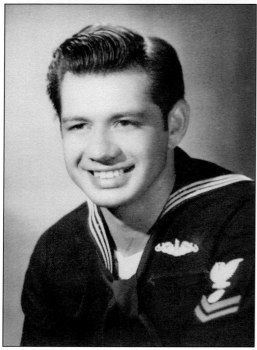

Robert Walter "Sonny" Ochoa served in the Navy from 1948 to 1969. He was stationed at the US Naval Submarine Base in Honolulu, Hawaii. During his years there, they spent six months at sea and then had six months on shore.

Sadly, it was not long after World War II that our young men were again called to battle, this time in Korea. Clyde Leroy "Boze" Savage served in the Navy from 1954 to 1958. He was aboard the ammunition ship USS *Jason*. From the ship, they watched the bombing over Korea. One night during a bombing, a cross appeared in the sky ahead of the ship, giving the sailors the feeling that their ship would be safe.

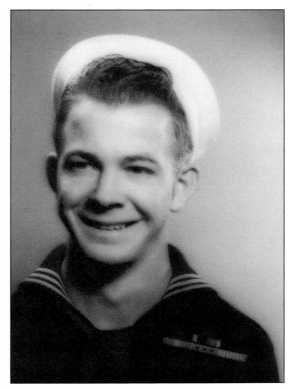

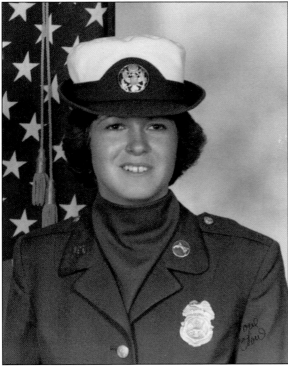

Mingus Union High School graduate Lori L. Hoffman joined the US Army Military Police in 1979. She received her basic training at Fort McClellan, Alabama, and was stationed at Arlington Hall, Virginia, for two years. She received her honorable discharge in 1982 after spending a year of overseas duty in Okinawa, Japan.

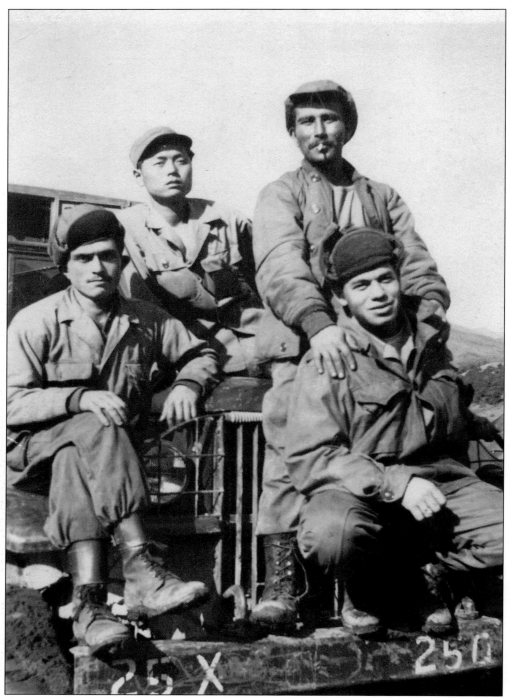

Another young man who served in Korea was Clint Self, whose family moved from Camp Verde to Cottonwood in 1934. Private Self, who saw a good deal of fighting, was photographed in 1952 with fellow peacekeeping soldiers—two Turks and one Korean. Self is the soldier squatting at lower right.

All in good fun, in August 1950, Cottonwood Lions Club members dressed up in their wives' clothes to put on a "Follies" to raise money for the Smelter City Fire Department. They are, from left to right (first row) Glen Wright, Glen Everett, Rusty Verretto, and Adolf Mongini; (second row) Jim Barrett, George Anderson, Russell Leadham, J.B. "Joe" Dick, Frank Massaro, and Ernest Ochoa.

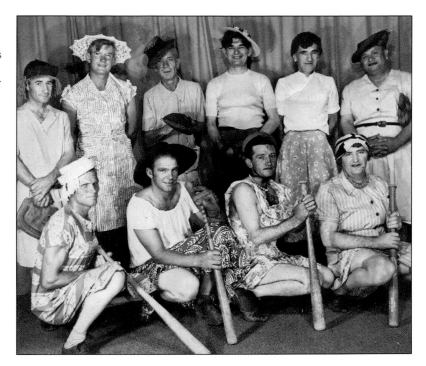

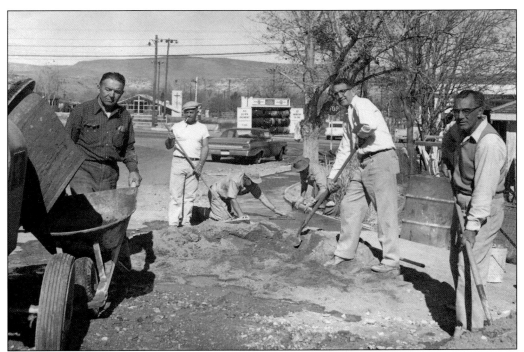

Physical labor was required for this Lions Club project, constructing a park on Cottonwood's Main Street at the corner of Willard, around 1960. On the left is John Muretic; Bill Simpson is on the right.

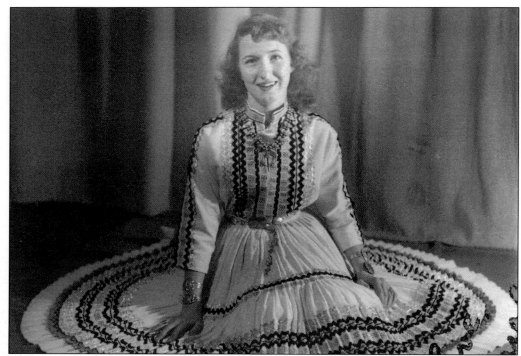

Students also did their part for good causes. As March of Dimes "Sweetheart" for Cottonwood High School in 1955, Carol Thompson's role was to encourage donations in the fight against polio. Carol later became Mrs. Don Godard.

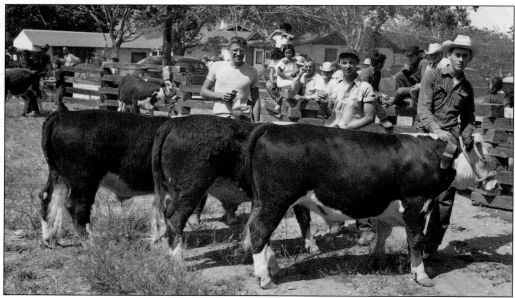

In 1952, the Future Farmers of America held their first competition and sale with the support of the Lions Club. Seen here with the three top steers are, from left to right, Jerry Griffin, Orin "Pinky" Marvin, and Don Godard, whose steer won the FFA Championship that year. Zeke Taylor was president of the Lions Club.

Zeke Taylor, with Holly Phillips at his knee, poses in front of Cottonwood Elementary School in December 1987. A Verde Valley native and a real working cowboy, Taylor was loved and respected for his good deeds. He was famous for his beef barbecues, which he offered as fundraisers for innumerable good causes. Zeke's barbecues raised the money to open the Clemenceau Heritage Museum. The Zeke Taylor BBQs, now continued by Don Godard, have become an annual tradition and an important fundraiser for the museum.

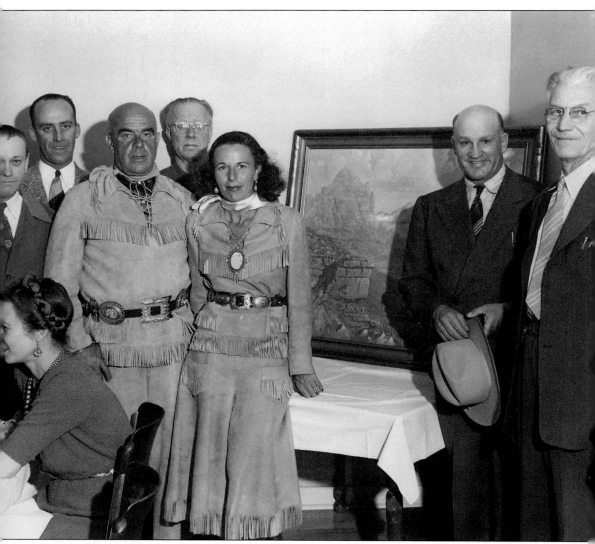

In the latter part of the 1940s, businessmen formed a Chamber of Commerce to promote tourism to the area. With mining and smelting winding down, tourism became important to the economic well being of the area. This Chamber Dinner honored Mr. and Mrs. Charles Ward for designing and printing material promoting Cottonwood. The buckskin-clad Wards are seen here with Rue Marshall, Frank Edens, Garvin Turner, Ersel Garrison, and Chamber president Thomas B. Jones.

Cottonwood got into the spirit of the Old West for a Kiwanis Bonanza Day fundraiser, Dollars for Scholars, in April 1964. Dottie Manfredi is having her shoes shined by Ralph Goltia, while Nick Manfredi mugs for the camera. The Kiwanis also sponsored annual Kids' Days and Penny-a-Pound Airlifts to raise money to buy glasses, shoes, pay dental bills, and test hearing for needy children.

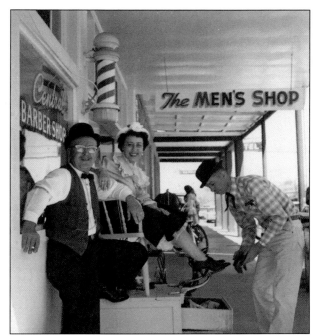

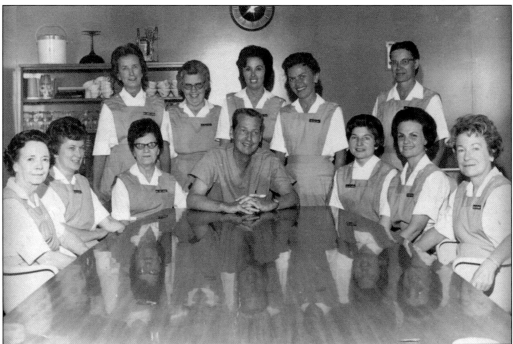

Hospital volunteers, known as candy stripers, became an important adjunct to care when the new, larger hospital opened in 1965. Gathered around the table is the original group of candy stripers, from left to right, (seated) Dot Potocki, Ruth Wright, Sibyl Greene, hospital chief of staff Dr. Daniel Bright, Kate Woodruff, Beverly Miller, and Peg Christy; (standing) Virginia Coffee, Mildred Geller, Beverly Finch, Carol Ogden, and Patti Fox.

Richard "Pat" and Eudora Patterson believed in serving their community. Pat was named Man of the Year in 1976. He was on the boards of the REA, 4-H club, and Verde Valley Fair, and helped acquire land for a new high school at no cost to taxpayers. Eudora organized and managed the first Chamber of Commerce, led in establishing the Verde Valley Guidance Clinic, introduced special education to the Cottonwood School District (where she taught elementary school for 20 years) and devoted 40 years to Cub Scouting.

Five

Doctor, Lawyer, Merchant, Rancher

Cottonwood's beginnings were as a farming and ranching community, and if it had not been for the mines and smelter in Jerome, there would have been no outlet for produce other than the military fort in Camp Verde. Additional means of earning a livelihood developed in the second decade of the 20th century with the establishment of the smelter towns of Clarkdale and Clemenceau, which drew people to the area. Whether the new arrivals lived in either of the two company towns or preferred housing outside the restrictions of a company, there arose a demand for additional services and products.

Farming and ranching were still important elements, but with the devastating effects of smelter smoke, which caused extensive damage to trees, crops, and soil, most farming and cattle raising moved farther out to Cornville, Page Springs, and Sedona. However, dairy farming remained a big business during the first half of the 20th century, and six dairies provided milk to the region.

To supply the demand for building during the boom years, lumberyards sprang up. The first in Cottonwood was Pugh Lumber on West Main Street near West Bend. After the yard burned, the family moved away. Next came Cottonwood Lumber Company, owned by the Edens. It was located on four lots on Main Street north of Pinal Street and was later bought by Babbitts; it remained in operation in that location until the early 1970s, when it moved out to the bypass. Sawmills provided the lumber. In 1945, Louis Peterson bought a small mill run by the Gibbons family and turned Peterson's Sawmill into one of Cottonwood's biggest industries for the next decade.

The opening of the Marcus J. Lawrence Clinic in 1939, and its expansion to a full hospital in the mid-1940s, provided work for doctors, nurses, and support staff. Its move to a larger facility in 1965, and subsequent additions, has made what is now called the Verde Valley Medical Center a major employer not only in Cottonwood, but also in the whole Verde Valley.

As the town grew, so did the businesses and services needed by the population. More and bigger schools were needed, employing more teachers and personnel. With incorporation, Cottonwood became self-governing. In addition to a mayor and city council, it needed a city manager, fire and police departments, and eventually departments for planning and zoning, public works, recreation, utilities, etc., making itself one of the larger employers today.

Despite, or because of, the shutdown of the mines and smelters, there has been phenomenal growth in the area. Cottonwood and the Verde Valley have been rediscovered, and tourism and retirees have replaced smelter smoke, supporting more business and services.

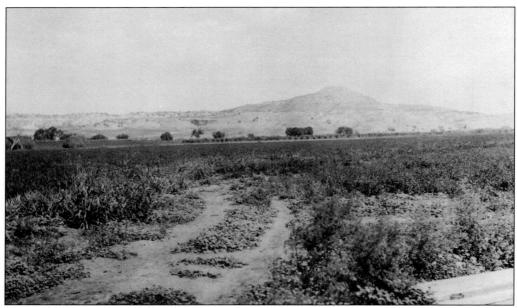

Smelter smoke damage is evident in this photograph of the Jordan ranch, dubbed "Sugarloaf" by daughter Stella; the hill in the background held Sinaguan ruins. The smoke ruined crops and the livelihood of Cottonwood farmers, who, led by W.A. Jordan, filed lawsuits against the smelters for damages. They eventually received a settlement.

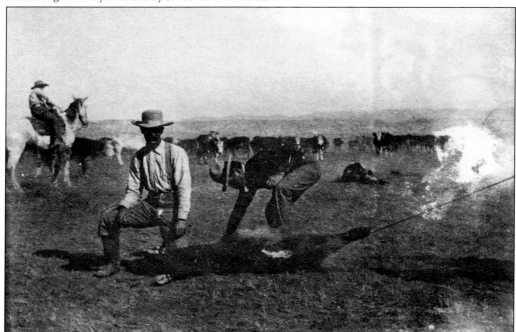

Cattle raising was a big business into the 1920s; thousands of cattle wintered in the area around Cottonwood and were driven up to the Mogollon Rim in the summer. Ranchers employed many hands for branding, roundups, and cattle drives. This 1886 photograph was taken in the Verde Valley near Cottonwood.

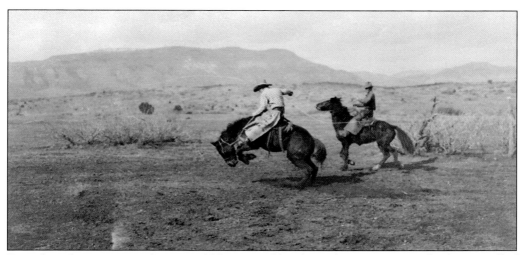

Part of ranching was rounding up wild horses and breaking them in. Prior to the fencing off of public lands, wild horses provided many a cowboy with his mount. Here, broncobuster Hank Starr breaks a wild horse, accompanied by Bill Gray, in the early 1920s. Bronco riding was, and still is, a popular aspect of every rodeo.

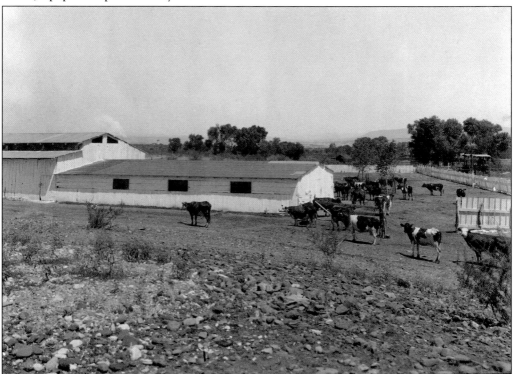

Charles Willard started the Jerome Dairy in the 1890s across the road from his mother's house. Around 1900, he moved the dairy to 120 acres farther east along the Verde River, now occupied in part by Camelot RV Park, which he had purchased from the Strahans. In 1920, it was sold to the Areghinis, who operated the dairy until 1957, when it closed due to competition from large out-of-town dairies.

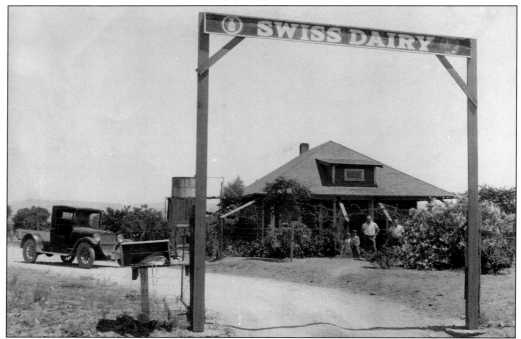

The Swiss Dairy, owned by John Zemp, later became Wiggins Dairy, located in Bridgeport. Competition was strong. When a new family moved in, dairy representatives nearly lined up at the door to get that family's business. When the mines closed and the population declined, several dairies closed too.

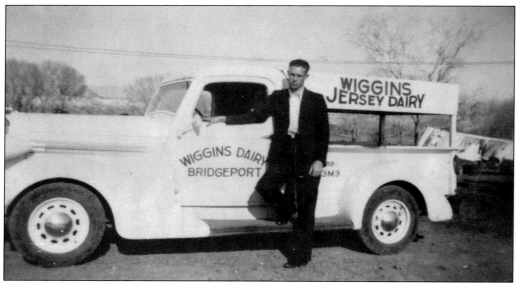

Debs Burchfield of Wiggins Dairy stands beside his delivery truck in 1938. Drivers and milk boys were up by 2:00 a.m. to milk 65 to 70 cows. Door-to-door delivery began at 5:00 a.m. Cows had to be milked twice a day, so the whole process began all over in the afternoon. There were no milking machines until the late 1940s. Dairies did not have to pasteurize until the mid-1950s, but cows were tested regularly for disease.

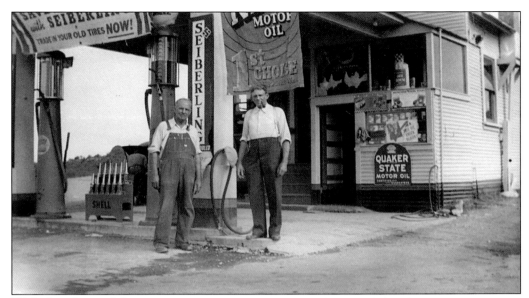

With the advent of the automobile came a whole new business—fueling, servicing, and repairing horseless carriages. At the south end of Main Street was a service station, which became Cottonwood Fuel & Feed in 1930. It was started by Mark Barker, on the left, seen here with his brother Jim. In 1939, Barker added a Purina Mills distributorship to the business.

Another view of Cottonwood Fuel & Feed shows the new river rock civic center across the street and the Methodist church, built around 1918, at the far right, which became a Baptist church, then a car dealership, and later, the city's recreation center. Mark Barker's loyal companion is Brownie.

Osley Ragel and his brothers ran a trucking company in the 1930s, hauling heavy equipment to and from the mines, smelters, and the Clarkdale railroad station. They also occasionally moved houses.

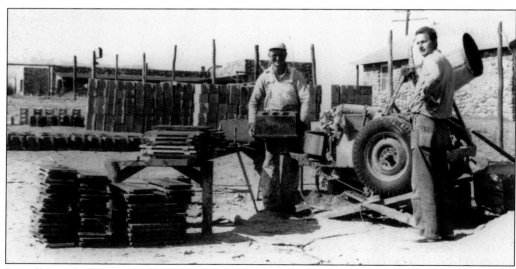

Russell McClafflin (right) and Lyle Holt made concrete blocks at a brickyard in Smelter City in the 1930s. As seen in the buildings in the background, river rock had become a popular building material, since it was free for the hauling. Concrete blocks, however, made good foundations.

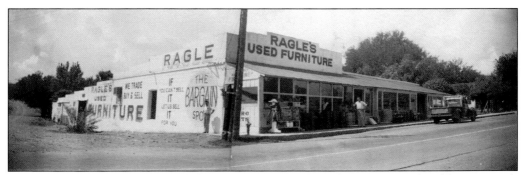

Osley Ragel, son of sign painter Phelan W. Ragel, started Ragel Furniture in the old Kovacovich Building in 1937. Dealing in used furniture turned out to be a very good business in the Great Depression and following war years. Osley had just opened a second store in Flagstaff in 1948 when he had a fatal heart attack driving back to Cottonwood. He was only 39 years old.

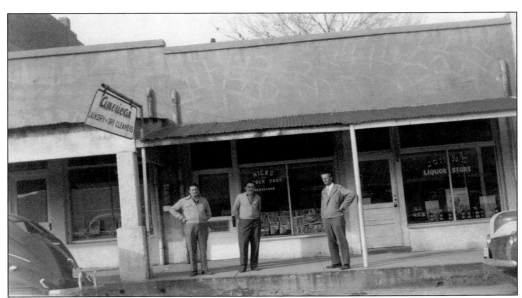

Owners posed in front of their businesses on Main Street around 1933. They are, from left to right, the unidentified owner of American Laundry & Dry Cleaners, barber Nick Matich; and James "J.O." Braley, owner of Braley's Motor Court across the street.

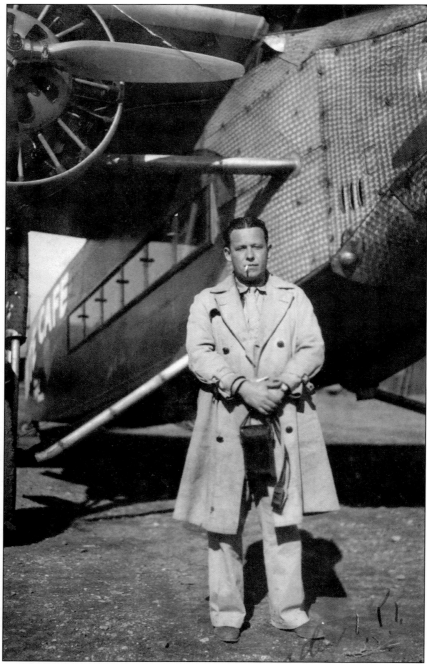

The pilot of this three-engine plane never really got off the ground. William A. Clark III, heir to the United Verde Copper Co., and Marcus Rawlins, operator of the Clemenceau Airport, formed a partnership to develop Verde Valley Air Lines in early 1932. Its purpose was "to establish, operate and carry on, between points within the United States and foreign countries, an air service for the carriage of the mails, passengers and freight." Unfortunately, Clark was killed in a plane crash, and the partnership and airline were dissolved.

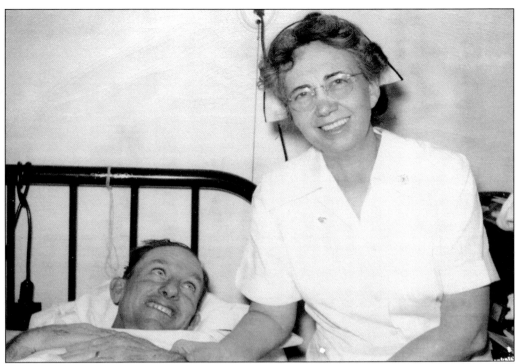

Martha "Mattie" Leyel puts a patient at ease at the Marcus J. Lawrence Hospital. Mattie came from the Jerome Hospital to become director of nursing in Cottonwood's new hospital. She was well loved by her fellow nurses, who attributed to her the patience of an angel, hands that healed the sickest patients, and the ability to remain calm in the toughest situations.

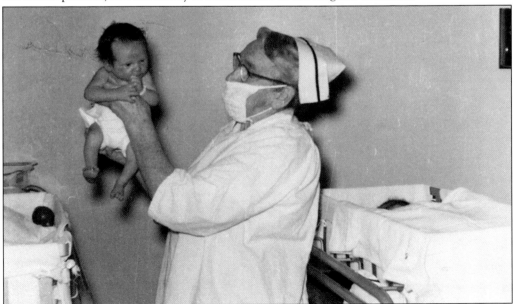

Nurse Barkie "Aunt Pop" Williams tends to a newborn in the maternity ward at the Marcus J. Lawrence Hospital in the mid-1940s, one of many she helped bring into the world.

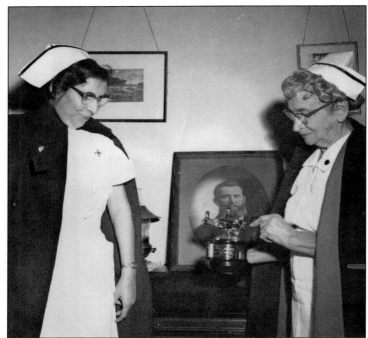

Mattie Leyel and Barkie Williams admire a leadership award presented to Mattie in 1955. The portrait behind them is of Barkie's grandfather, who was said to be the last survivor of the Charge of the Light Brigade in the Crimean War, 1854–1856.

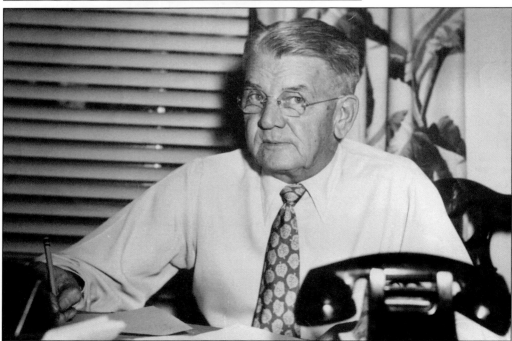

Dr. Arthur C. Carlson became first chief of staff in the new Marcus J. Lawrence Memorial Hospital after having served for many years as chief surgeon in the United Verde Copper Co. hospital in Jerome. Other doctors were Drs. Walter Edwards, William Bates, Daniel Bright, and Owen Cranmer. The hospital had an excellent reputation, often referred to as "the little Mayo of the west."

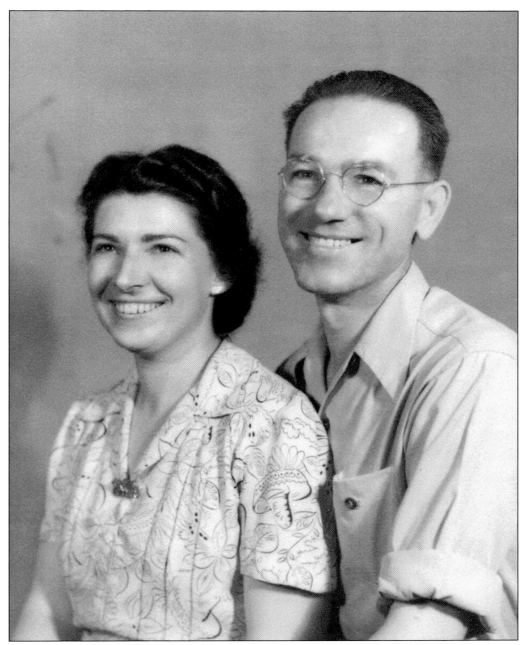

Louise and Tony Kovacovich owned the Verde Grocery on Main Street, which they bought in 1945 from Debbie Calvert. Tony's brother, Emil, opened the first Buick dealership in Cottonwood in 1948, and his uncle Emil had built Kovacovich Mercantile in 1917, the first concrete building in Cottonwood. The family emigrated from Croatia in the early 1900s.

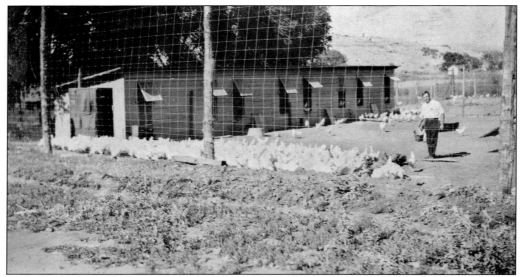

Walter and Malinda Kallsen built a chicken ranch in Bridgeport in 1947. They had hundreds of Leghorns and sold the eggs to markets in Flagstaff and locally for the next decade.

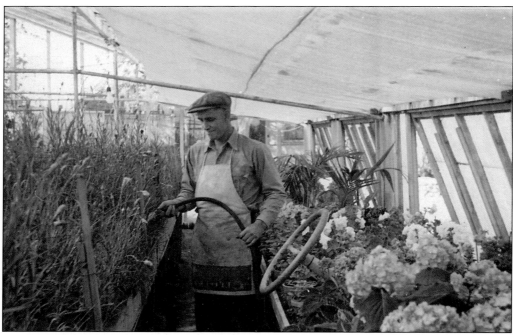

John Calvert tends to his flowers in Verde Floral, a business he and his wife, Debbie, started in 1939. Cut flowers were kept cool in an old icebox and steam heat for the greenhouse was hand operated, which meant the Calverts had to get up three times a night to let steam run through the pipes. Generations later, with various additions and renovations, the business remains in the same family at the same location.

It is January 1949, and W.A. Fredrickson removes the canvas tarp used to protect the mail he brought over Mingus Mountain to the Clemenceau Post Office. He will then reload his vehicle with mail from Clemenceau going to Prescott and beyond. Just to the right of the post office is Clemenceau's gazebo.

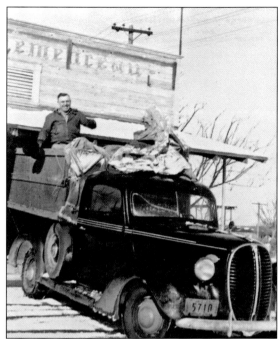

Richard Brann, seen here at the typesetting machine, was the first publisher of the *Verde Independent*. He started the paper in 1948 and bought a government surplus World War II Quonset hut for offices. He set the building on a river rock foundation in Smelter City, where, enlarged and modernized, it remains to this day, still headquarters for the *Verde Independent*.

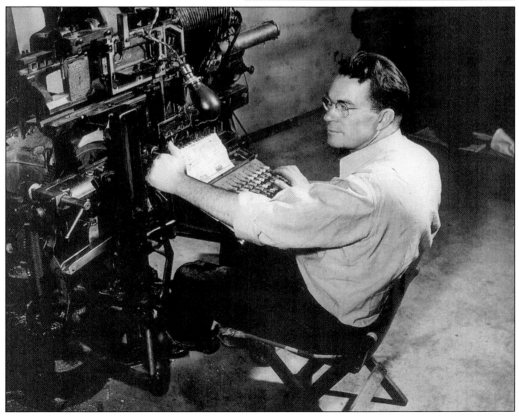

In 1945, Louis Petersen bought the small Gibbons sawmill and moved it to 40 acres at what is now the junction of Main Street and Arizona Route 89A. It was the largest industry in Cottonwood in the 1950s, with more than 70 employees. Petersen family members and employees gathered for this photograph atop the largest log received at the sawmill.

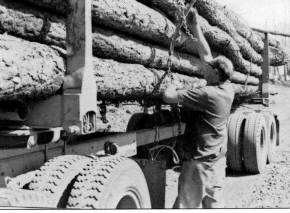

Ted Simpson secures logs for a trip to Petersen's sawmill. Trees were logged from the rim, east of Camp Verde, some 40–50 miles away. The mine in Jerome was their main customer. When that closed, the Cottonwood sawmill was no longer economically viable, and it, too, closed shop in 1958. Sawmill Village is located on the former Petersen property, and one of the original saws is on exhibit at the Clemenceau Heritage Museum.

Back from World War II, Glenn Wright opened this cabinet shop in Smelter City. A native Arizonan, Glenn was the fourth of 11 children. In addition to cabinetry, he knew a great deal about farming and served as a supervisor of the Bridgeport Soil Conservation District.

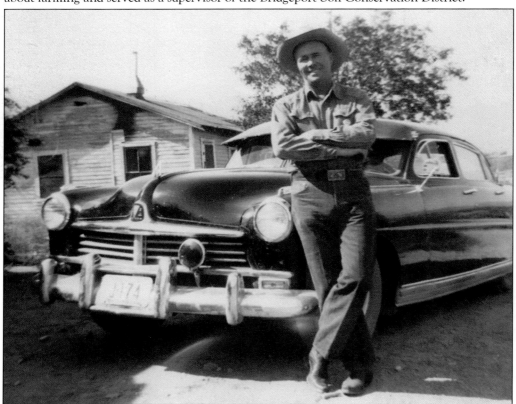

Sheriff Jerry Foster proudly shows off his official sheriff's car in 1950. Prior to incorporation, Cottonwood depended on Yavapai County to provide police protection. Jerry was sheriff for the Cottonwood area for several years.

A crowd of 5,000 came out to watch the Farm Built-In-A-Day, a dawn-to-dusk transformation of 25 run-down acres into a model modern farm, on April 27, 1948. The erosion and neglect of the Bridgeport property had made it affordable for disabled veteran Robert G. Hardgrave and was the perfect opportunity to show valley residents how to put almost every conservation recommendation into practice.

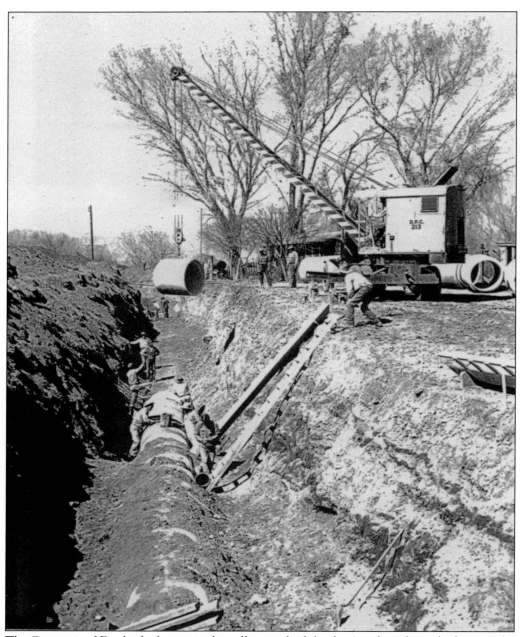

The Cottonwood Ditch, the largest in the valley, was built by the Apache tribe and taken over by the Anglos in 1877. Fed by natural gravity flow from the Verde River, farmers depended on it to raise their crops. The old wooden flume became too expensive to maintain, so in 1948, concrete pipe was installed from the Cottonwood Jail to Siler Wash, and the entire ditch improved at several different locations.

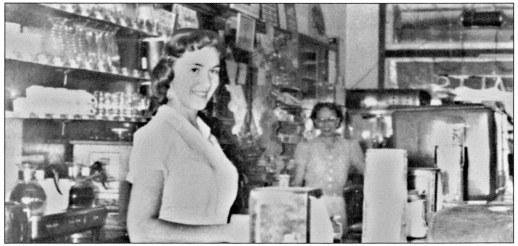

Lillian's Sweet Shop, owned by Lillian Van Gorder, served as Cottonwood's bus stop, as well as a good place for a bite to eat. Lillian also provided meals for the occasional inmate of the Cottonwood Jail. Lillian is in the background, assisted by student JoAnn Allen Connolly.

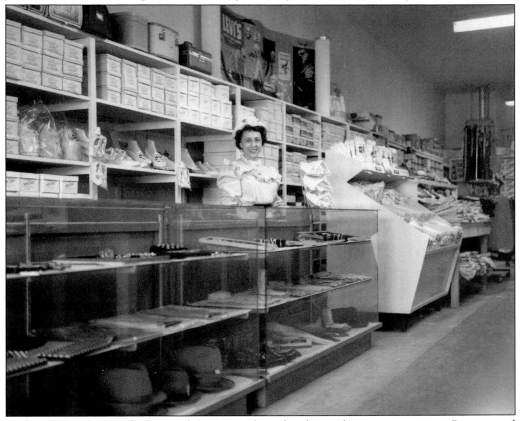

Nick and Dorothy Manfredi owned the Men's Shop, the place to buy western wear in Cottonwood for most of the 1960s. Elvis Presley purchased some turquoise jewelry here when he made the movie *Stay Away Joe*, filmed partially in Cottonwood in 1967.

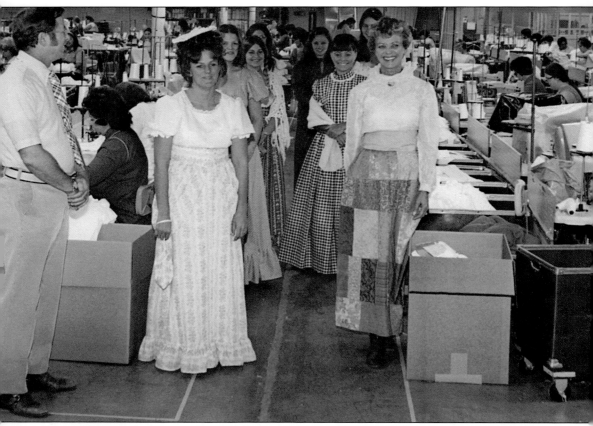

Penn-Mor was a major employer in Cottonwood from 1969 to 1976. The company built a large plant on South Sixth Street and employed about 100 workers. It manufactured girls' "Dream Puff" briefs and cotton pullover undershirts for infants, shipping 1,000 dozen finished pieces per week to its main plant in Tempe. The reason for the fancy get-ups is unknown.

Six

TIME OUT

After having traveled in wagon trains for weeks, or sometimes months, the problems for the early settlers upon arriving in Cottonwood had just begun. They then had to attend to their immediate needs of shelter, clearing land, and eking out a living from scratch. With none of the conveniences and gadgets we have today, there was little time for leisure. Despite the hardships, even in the very early days, there were church services, Sunday picnics, and even dances that sometimes went on all night, accompanied by a fiddle or two. As early as the 1880s, the Fourth of July was the occasion for big celebrations, which included picnics, parades, and fireworks.

The one-room school was a social center as well as classroom. Baseball, ante-over, and mumbly peg were recess games, and spelling bees were held on Friday nights. When a dance was given, seats were arranged along the sides of the room or outside.

With many single men working in the nearby smelters, Cottonwood could be a rough place. Workers wanted to be entertained after a hard day, which meant that bars and pool halls flourished, and with the coming of Prohibition, came bootlegging. Cottonwood also had its "soiled doves" and a town madam, "Jew Annie," who charged $2 and was described as "Five-foot-one-inch tall, bow-legged, with much makeup, and purple socks."

For more wholesome entertainment, there were turkey shoots, spike drives, hoop shoots, pole transformer climbing, carnivals, rodeos, bake sales, baseball (sponsored by UVX), and from the late 1920s, skating on the second floor of the Willard building. There were even races to Jerome by rival car dealers.

The Pavilion and the UVX clubhouse both offered dancing, and the former was also a venue for boxing matches. The opening of the Rialto Theater for movies and vaudeville offered still more options for entertainment, as did band concerts in the gazebos in both Cottonwood and Clemenceau. In warm weather, there was swimming in the Verde River, which also offered opportunities for fishing.

As Cottonwood spread out and the automobile cut down distances, new entertainment options appeared—a tavern in Bridgeport and dance halls in Cornville and Geary Heights on the road to Clarkdale. Today, there are numerous venues, such as the Verde Valley Fairgrounds, Dead Horse State Park, Cottonwood Recreation Center, Yavapai Community College, the Old Town Center for the Arts, Little Leagues, and many restaurants and bars that offer entertainment and leisure activities to suit everyone's interests.

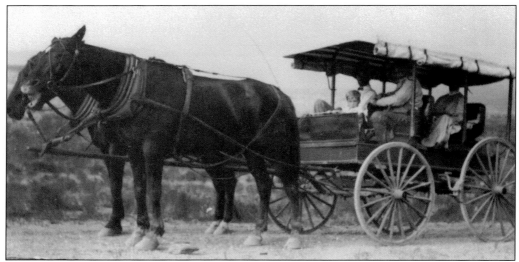

Grandpa and Grandma McMillan are on their way to Montezuma Castle by wagon, pulled by a pair of mules. The Sinaguan ruins were among the preferred sites for a Sunday afternoon outing and picnic, a favorite activity for the early settlers. The year was 1907.

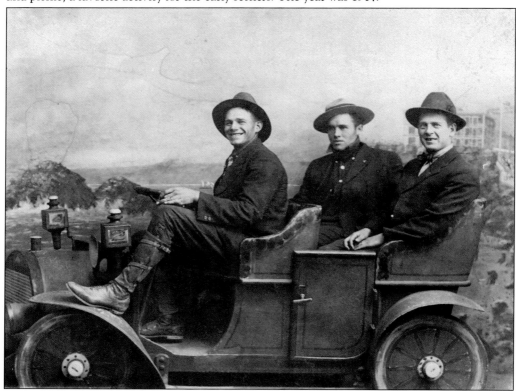

The automobile would become a necessity, but back in 1916, only a very few could afford the luxury of owning a horseless carriage. Pretending was fun too, as in this studio automobile with painted backdrop. At the driver's seat is Herman A. Arnold, accompanied by his brother, Jack, and a Mr. Anderson.

Sumner Jordan received this graphic poster from a friend, Paul Smyly, warning him of the dangers of dissipation, whether seriously or in fun, is uncertain. What is certain is that among some religious folk, there was a strong bias against any form of dancing, not to mention gambling and drinking, and Sumner was the grandson of a Baptist preacher.

Revival meetings were popular among many who found the preaching inspiring. It was also an opportunity to get together with neighbors, catch up on news, and enjoy some good food provided by the women between services. This 1920 revival service by preacher Will H. Chappell promises that attendees will receive a blessing.

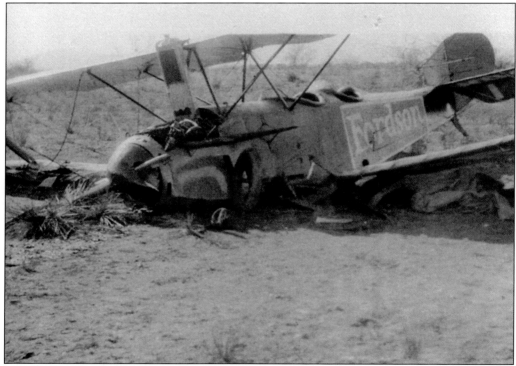

Some preferred more daring activities than attending revival meetings. Was this the result? For Ersel Garrison, flying was a hobby and a passion. This was his first airplane, which crash-landed shortly after a take-off from a level spot in Smelter City, due to a cold engine. Ersel's partner, Andrew Tipton, was the pilot, accompanied by Ersel. Fortunately, no one was hurt.

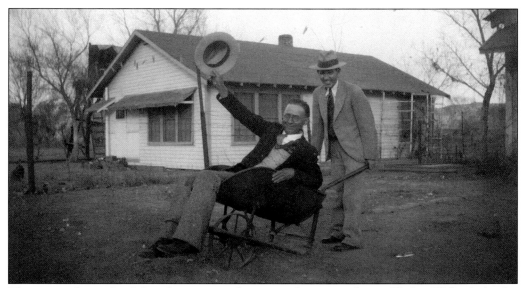

There were those who did not have to spend money to have a good time. Phelan W. Ragle (in the wheelbarrow) and an unidentified friend are hamming it up outside Ragle's Cottonwood home on Christmas Day 1928.

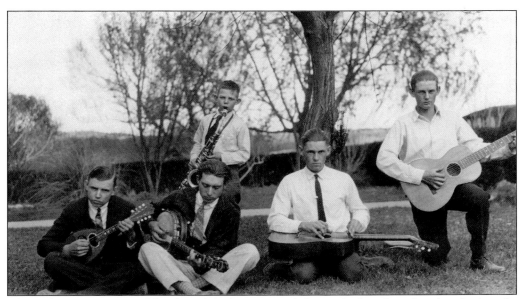

The Jordans were a musical family and the boys enjoyed playing for friends and in church. At right are Sumner and Edgar on guitars and their nephew Edward Stone on tenor sax. Their friends on mandolin and banjo are unidentified.

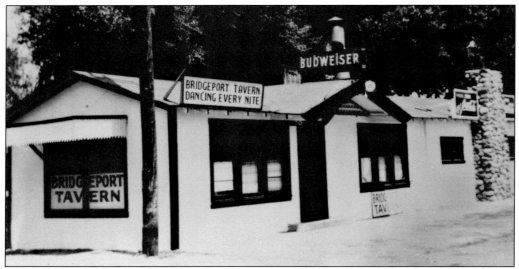

Despite the religious fervor of some, dancing remained a popular pastime, and a popular venue was the Bridgeport Tavern, a roadhouse that advertised dancing every night. Local bands made up of teenagers and businessmen also played gigs at the UVX Clubhouse, Bungalow, and Willard Hall, and later at Geary Heights, Cornville, and the Pavilion in Clarkdale.

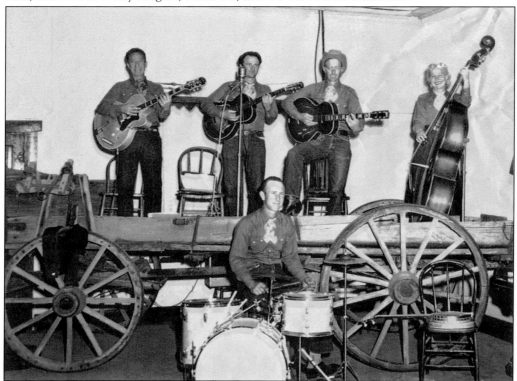

There was always live music for dancing, and the Sobleys had a popular band that often played at the Bridgeport Tavern in the 1950s. Pictured is the full complement, from left to right, Carl Sobley, Leon Guinn, Hubert Cluff, Cleo Sobley, and Jack Sobley in front.

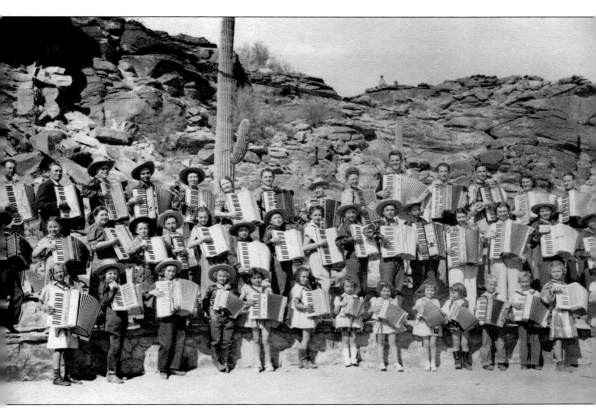

Rachel Becchetti, daughter of theater owner Joseph Becchetti, organized this accordion group, shown here at the Arizona Accordion Club's third-annual picnic in Phoenix on April 16, 1939. The band played at Montezuma Well at the Annual Pioneer's Picnic once a year. Among the musicians are Phyllis Garrison, Anna Fonara, Alberta Carlson, Margaret Barker, Daisy Williams, and Markie Barker. Rachel is fifth from the left in the back row.

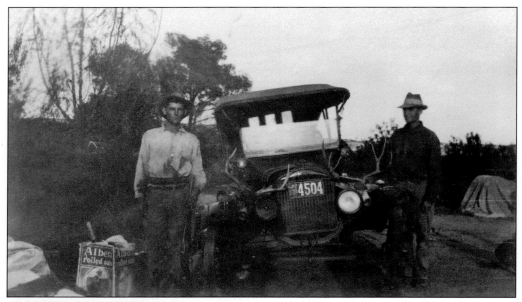

Hunting was, and still is, a sport enjoyed by many, and it put food on the table to boot. Sumner Jordan and an unidentified friend return from a successful hunt in 1919 with stags tied to the fenders. In the early days, the Cottonwood area was teaming with game, a source of food and sport.

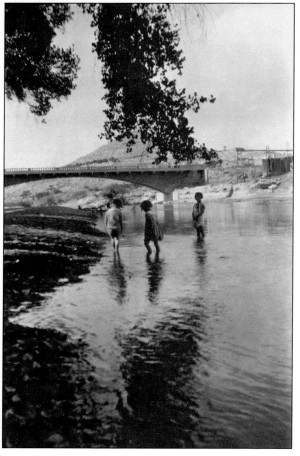

On hot summer days, nothing could beat a swim in the Verde River under the Cottonwood trees. The youngsters here are just west of the bridge at Bridgeport near the former Thompson Crossing. The hill in the background is called Sugarloaf. It was another site of Sinaguan Indian ruins, favored by children, who enjoyed hunting for arrowheads and pottery shards.

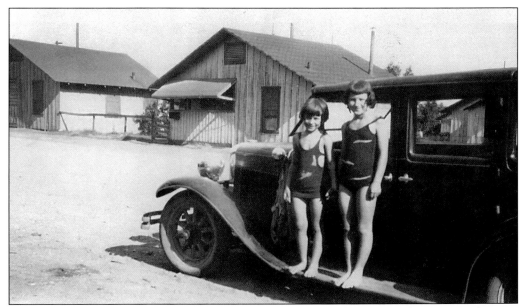
Bathing beauties Lois and Alma Stout are ready for a summer's day outing. There was no shortage of swimming holes along the Verde River, but traveling by car, the girls may have been heading out to Oak Creek in Cornville.

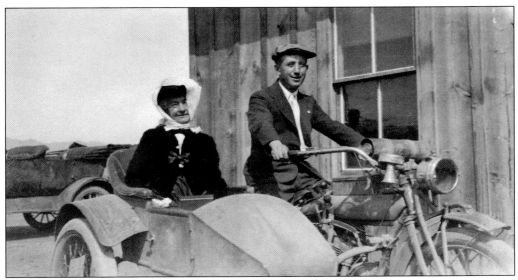
Annie Jordan is taken out for an afternoon spin by her nephew Allan Bristow, who was a real motorcycle aficionado and loved to share his passion for the machine.

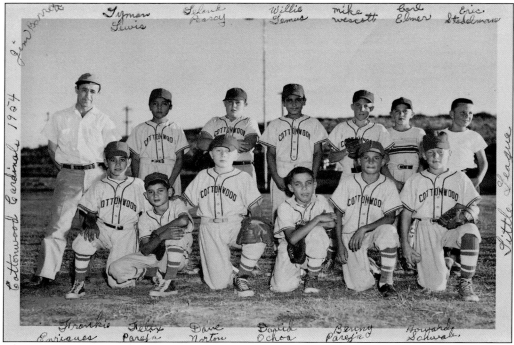

In the 1950s, Little League baseball became a popular pastime for young boys, encouraged by parents, who served as volunteer coaches. In 1954, the triumphant Cottonwood Cardinals gathered for a formal photograph with their coach, Jim Barrett.

Kids' Day, October 4, 1952, brought most of the area children to the field behind what is now Cottonwood's City Hall, in the hope that his or her name would be drawn for a bicycle in an event sponsored by the Kiwanis.

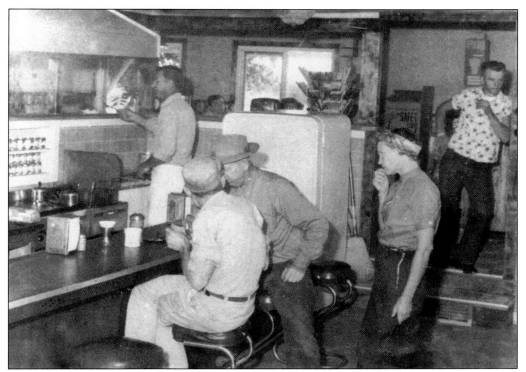

"Go Where the Gang Goes" was the motto of the Chatterbox Café, a favorite teen hangout throughout the 1950s, and home of Hol'N One donuts, pizza, burgers, barbeque, and homemade pies. The photograph is from 1957, and Chuck Garrison, son of Ersel and Jennie Willard Garrison, is standing by the jukebox.

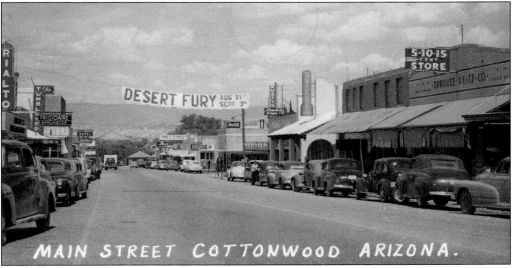

Movies were a popular form of entertainment, made even more so by offers of free dishes or cosmetics. *Desert Fury*, starring Lizabeth Scott, John Hodiak, Mary Astor, and introducing a young Burt Lancaster, was filmed on location in Cottonwood and merited a special banner when it came to the Rialto Theater in August 1947.

> COMPLIMENTARY TICKET
>
> This Ticket and One Paid Adult Admission Will
>
> ## ADMIT ONE FREE
>
> ## RIALTO THEATER
>
> Cottonwood, Arizona
>
> "A HOME-OWNED INSTITUTION"
>
> Good Any Show Any Time Until July 1, 1932

Joseph Becchetti, owner of the Rialto Theater, also filled the dual role of truant officer and janitor at the Clemenceau School. He often offered free movie passes to students as incentives for good attendance.

Everyone loves a parade. The Christmas parade has been a Cottonwood tradition since 1954. Schoolchildren and nearly every organization in town are represented by floats and costumed marchers parading along Main Street. Santa, at the parade's finale, always marks the official beginning of the holiday season for Cottonwood.

Seven

THE CITY

Rather than becoming a ghost town when the mines and smelters closed following World War II, Cottonwood stood on the verge of its greatest boom. With the smoke gone, the land responded to conservation methods. People heard of the Verde, came to look, and liked what they saw—the chance to make a good life amid beautiful scenery—a simpler way of life where a person felt close to basic values. New highways, tourism, scenic attractions, and retirement were all forces leading to a period of widespread development. Pastures, fields, and hillsides filled with housing and shopping centers. The largest housing development, Verde Village, started in 1968 by the Queen Creek Land & Cattle Company, more than doubled the area's population.

In 1958, Phoenix Cement Company built a plant in Clarkdale to provide material for Glen Canyon Dam. While it was an economic boon for the area, it was not so for Cottonwood's commercial center. Noisy cement trucks passing through Main Street from dawn to dusk annoyed businesses and residents alike, who petitioned for a truck bypass. With the bypass came new development away from Cottonwood's historic center. By the mid-1980s, Cottonwood's "Old Town" was a sorry-looking sight with many vacant, run-down buildings and nearly empty streets—a hangout for derelicts and vagrants. Apart from Cottonwood's unimposing city hall, city council building, and police department, most other public facilities, such as the hospital, library, fire department, and recreation areas, had moved away from the center.

In the early 1990s, Old Town merchants formed the Old Town Association, and with the backing of the city, joined the Arizona Main Street Program in an effort to revitalize the former heart of Cottonwood. Grants were obtained to apply for listing in the National Register of Historic Places, for street and sidewalk improvements, additional parking, and for a trail connecting Old Town with Dead Horse State Park on the other side of the Verde River. All of these were accomplished within 10 years.

Today, Old Town has become a center for shopping, art, music, and cafés, with few vacant spaces. Viniculture has arrived in the Verde Valley, and tasting rooms and restaurants are promoting the local product. There are plans for a boutique hotel in a former grocery store and a microbrewery in a former gas station. Special events draw people to Old Town, where they now find coffee, olive oil, bread, clothing, gifts, furniture, countertops, yarn, beads, glitter, bicycles, and antiques. Lawyers, realtors, and engineers have offices there, and the Old Town Center for the Arts, in a historic church on Fifth Street, has become a center for quality concerts and other entertainment offerings.

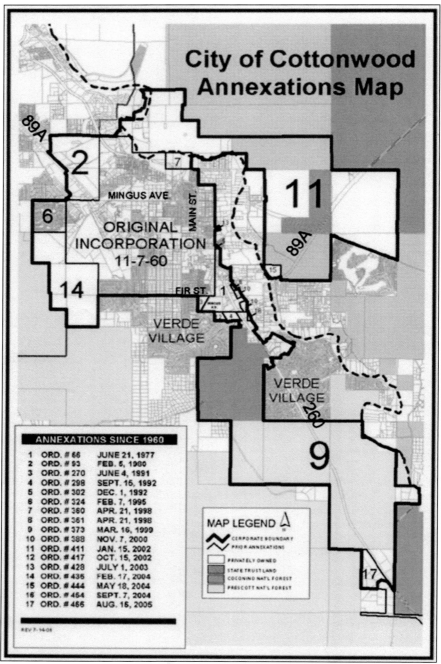

Cottonwood's incorporation in 1960 included the original commercial district and adjacent residential blocks, Smelter City and Clemenceau, plus a considerable amount of land south to Fir Street. Historic Cottonwood occupied only a small portion in the northeast corner of the original incorporation area. Since 1960, a great deal of territory has been added to the city of Cottonwood. However, the Verde Villages, which have a Cottonwood address and a population equal to that of the city, have thus far refused to be incorporated with Cottonwood.

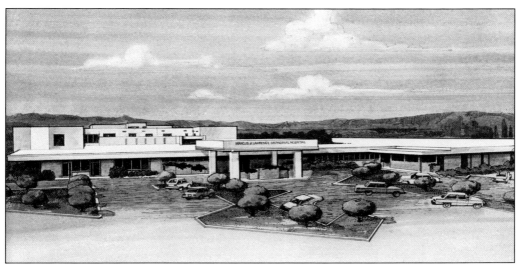

On September 26, 1965, patients were transferred from the hospital in Old Town to the new 50-bed, $1.5 million Marcus J. Lawrence facility located southwest of Cottonwood on Willard Street on 25 acres of land donated by Mr. and Mrs. Ersel Garrison. In 1979, the first two-story addition to the new hospital increased the beds to 99.

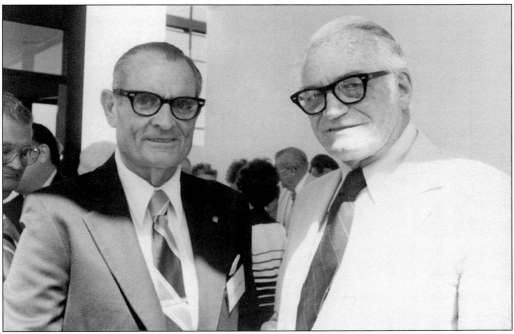

Arizona's favorite son, Sen. Barry Goldwater, was the featured speaker at the dedication in May 1980 of the new wing, named after hospital administrator Roland Wilpitz, left, who had served in that position since 1957. By 1999, the hospital had grown further, and its name was changed to the Verde Valley Medical Center; only the original wing retains the name of Marcus J. Lawrence.

No history of Cottonwood would be complete without mention of Charles Stemmer, seen here with his wife, Bessie. A friend of Charles Willard, Stemmer helped lay out Main Street and the Willard Addition, served as Cottonwood's postmaster from 1924 to 1952, was a founding member of the Progressive Association, and remained active in civic matters throughout his life. In 1960, he was a passionate advocate for incorporation, claiming it was "now or never."

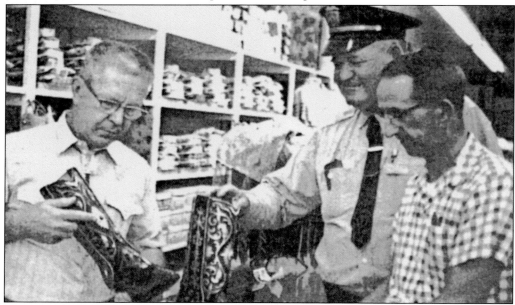

Nick Manfredi (left) of the Men's Shop in Cottonwood, points out brilliant star sapphires and other gems on $10,000 Tony Lama boots to Cottonwood Police Chief Buck Snoddy and Al Duggan, director of the Indian Bible Academy. The bejeweled boots were on display at the Men's Shop in July 1965.

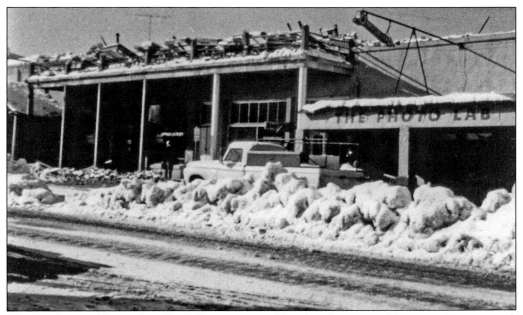

The Big Snow of December 13, 1967, was a record breaker that created havoc in Cottonwood. It was the largest recorded snowfall in Cottonwood's history. One of the hardest hit was the Willard Building at 1010–1012 North Main Street, which lost its second story under the weight of the snow.

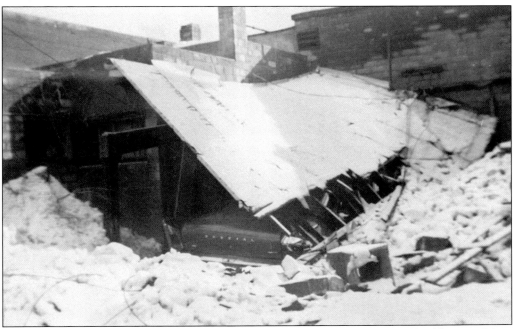

Many old wood frame buildings collapsed, and the roofs of several commercial buildings on Main Street caved in. Some of oldest barns in the valley were lost under the weight of the snow. The tons of the white stuff made roads impassable for over a week. Snow was finally shoveled into the middle of Main Street so pedestrians would have access to the stores.

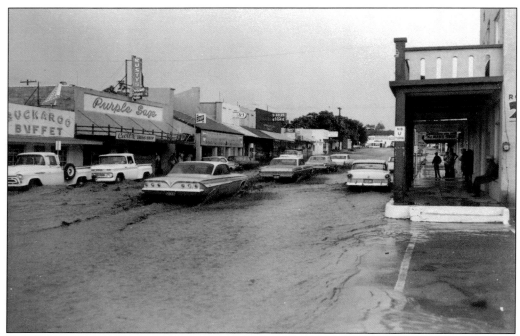

Floods were not uncommon in the Verde Valley, and heavy rains created havoc on Main Street in Cottonwood, as with this storm in the summer of 1964. Shops on the north side of corners frequently found their floors flooded, as well as the sidewalks and streets.

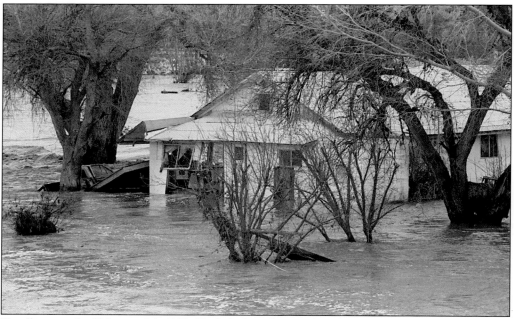

Headlines in the February 26, 1993, *Verde Independent* read, "Old-timers agree: this was Valley's worst flood ever." Water rose to the rafters in riverfront homes, as here in Bridgeport, as a 26-mile stretch of the Verde River from Clarkdale to below Camp Verde swelled to a width of one-half mile, and the event made the national news. (Courtesy of Dan Engler.)

A fire that destroyed McDonald's Lumber Yard in the early 1960s drew a crowd of onlookers, including Lenor and Cecil Nelson and their three children. All the fire-fighting equipment that could be mustered was there to put out the blaze. The lumberyard was on the site of Cottonwood's Planning and Zoning Department and Utilities Administration at 111 North Main Street.

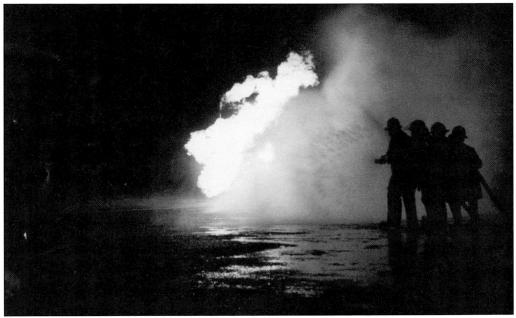

In December 1998, fire struck once again in Old Town Cottonwood, this time destroying the former Rialto Theater, which had had some fame as the oldest single screen movie house in continuous operation in the country. The site has since been rebuilt into the Tavern Grille, a popular sports bar and restaurant.

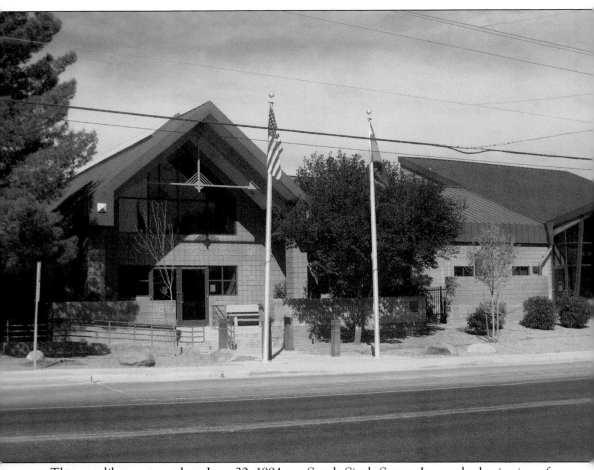

The new library opened on June 20, 1994, on South Sixth Street. It was the beginning of a computerized system. On October 15, 2008, the Cottonwood Public Library added 8,750 additional square feet. This addition, devoted to Youth Services, was dedicated to longtime city manager Brian Mickelsen.

The Cottonwood Senior Center moved into the renovated Clemenceau smelter engine repair shop in January 2006. Originally, train tracks ran along both sides of the building, and there was a huge pit at one end so engines could be worked on from underneath.

Cottonwood's police and fire departments moved into a new public safety building in 2009 on Sixth Street. The police department has grown from one sheriff and one highway patrolman to 30 sworn officers. From all-volunteer firefighters at the time of incorporation, the fire department now has 24 linemen, two fire prevention officers, the fire chief, and an administrative assistant.

The new Cottonwood Recreation Center opened on South Sixth Street, next to the Cottonwood Library, on May 1, 2010. It boasts exercise facilities, a dance studio, community events hall, gym, game room, climbing wall, indoor leisure pool, and the latest fitness, strength, and cardio equipment. (Courtesy of Beaches on Location.)

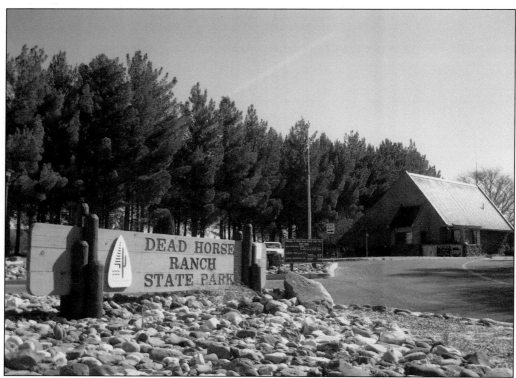

Cottonwood's Dead Horse Ranch State Park is a six-mile area along the Verde River. A former ranch, it became a state park in 1973. It boasts a unique ecosystem, one of less than 20 such riparian zones in the world. Its 423 acres are ideal for camping, mountain biking, hiking along the Verde River, canoeing, picnicking, fishing, or wading in the cool water.

The Old Town Association Board poses in Old West costumes for this picture in 1993 in front of their office in the old jail with the first Main Street director, J.B. Urban. They are, from left to right, (first row) Bobbie Harris, Debbie Klawitter, J.B. Urban, and Kia Fender; (second row) Carla Ponce, Charles Anderson, Tom Vaughter, and Helga Freund. Absent were Tim O'Brien, George Pardee, and Stan Warcyk.

The old jail, built by the county in 1929 and later Cottonwood's police headquarters after incorporation, was spruced up and became Old Town's visitor center. The landscaping was designed and executed as an Eagle Scout project in 2001. The "Jail Trail" to Dead Horse State Park begins here.

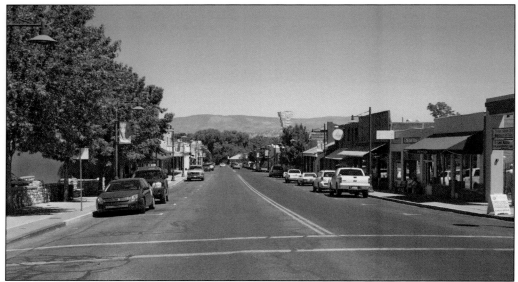

Main Street storefronts have, for the most part, remained much the same as when they were built in the 1920s–1930s, but new landscaping, wider sidewalks, new streetlights, and a paved parking lot have contributed greatly to Old Town's overall appearance. It now has a vibrant mix of specialty stores, galleries, restaurants, and services, and hosts monthly art walks and various annual events.

The old Arnold auto supply shop on Main Street, pictured on page 33, has seen several businesses pass through its doors. It is now the home of Arizona Stronghold's wine-tasting establishment.

The pioneers who settled here
To seek a better life
Deserve our highest gratitude,
For all their toil and strife.

The little town they left for us,
Is now a thriving gem,
A city that has made us proud,
We owe our thanks to them.

Where donkeys wandered through the streets
And church bells rang on Sunday,
Kids played games on weekends
And walked to school on Monday.

But now those times have passed us by
And many things are new,
Our town is filled with stores and shops
With lots of things to do.

—Clint Self, 2010

Clint Self is a native son of the Verde Valley. After serving in the military, he worked for and retired from Cottonwood's Public Works department. Self is an author, poet, and musician who composed his "Tribute" especially for this history.

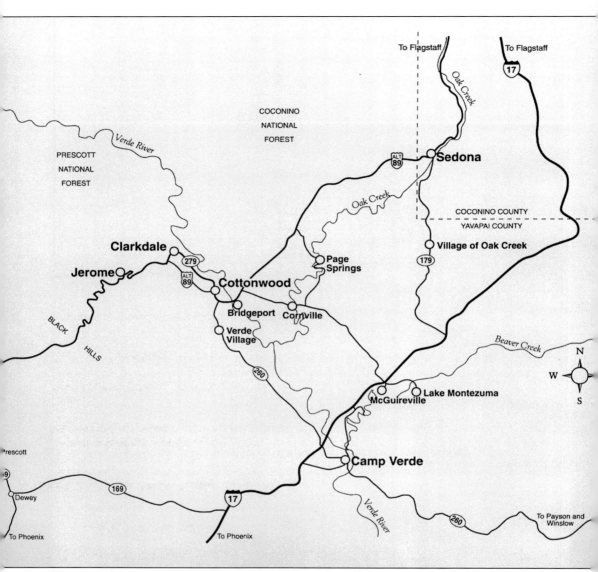

This map shows Cottonwood's location in the Verde Valley. Cottonwood is located in Yavapai County about halfway between Flagstaff and Prescott, Yavapai's county seat.

Bibliography

Goddard, Jesse, Sam Benedict, and Pauline Boyer. *Pioneer Stories of the Verde Valley*. Camp Verde, AZ: Camp Verde Historical Society, 1972. Fourth edition.

Laird, Linda. "Historic Resources Inventory, Cottonwood, Arizona, Final Report." Tucson, AZ: Linda Laird & Associates, 1986.

Larson, Julie. *The History of Cottonwood-Oak Creek School District No. 6*. Unpublished.

League of Women Voters of Sedona-Verde Valley. "This is the Verde Valley." Sedona, AZ: 1999.

Simons, Isabel, ed. "Cottonwood, Clarkdale and Cornville History." Cottonwood, AZ: American Association of Retired Persons, 1984; copyright and reprint Cottonwood, AZ: Verde Historical Society, 1995.

Stein, Pat H. "National Register of Historic Places Registration Form," Cottonwood, AZ: Old Town Association, 1999.

Willard, Don. *An Old-timers Scrapbook*. Sedona, AZ: Sedona Historical Society, 1984.

Verde Valley Horseman's Council Oral Histories. Interviews by Cynthia Buchanan. Tape recording. 1982–1983. Transcribed by Verde Historical Society, 2002.

Discover Thousands of Local History Books Featuring Millions of Vintage Images

Arcadia Publishing, the leading local history publisher in the United States, is committed to making history accessible and meaningful through publishing books that celebrate and preserve the heritage of America's people and places.

Find more books like this at
www.arcadiapublishing.com

Search for your hometown history, your old stomping grounds, and even your favorite sports team.

Consistent with our mission to preserve history on a local level, this book was printed in South Carolina on American-made paper and manufactured entirely in the United States. Products carrying the accredited Forest Stewardship Council (FSC) label are printed on 100 percent FSC-certified paper.